Portraiture at Home

ISBN 0 85242 488 4
First published 1977

© **R. H. Mason, 1977**
© **Argus Books Ltd**

Printed and bound in Great Britain by Cox & Wyman Ltd, London, Fakenham and Reading

Portraiture at Home

R. H. Mason, FIIP, Hon FRPS

formerly Editor of *Amateur Photographer*,
Past President, Royal Photographic Society,
Past President, Institute of Incorporated
Photographers

 FOUNTAIN PRESS

Contents

Introduction

IT WAS the custom at one time to make a trip to a professional photographer's studio every few years or so. Not many people had the facilities for taking portraits at home and fewer still had the necessary skills. Today, thanks to fast films, versatile cameras and portable lighting, anyone can take portraits almost anywhere. Moreover they are generally much better characterizations than the stiff and formally posed studio pictures of the past, mainly because they are more natural and spontaneous.

There is a popular impression that photography is a very expensive hobby but this is not necessarily so. Like fishing, golf or any other leisure pursuit it can be costly or it can be comparatively inexpensive, but in every case it is the thought, enthusiasm and creative skill put into it that really counts. Many very fine pictures have been taken with simple cameras and even more bad pictures have been taken with the most expensive models.

This book sets out to show that portraits at home, both indoors and in the garden, are not only possible but comparatively simple and with a quite modest outlay in cash and in trouble. It describes the minimum apparatus required to improvise a studio in the drawing-room or on location as well as the requirements for doing really artistic portraiture, instead of snapshots, in the garden. From then on it deals with the more important aspects of portraiture—lighting angles, posing, composition and presentation.

Year after year in the competitions staged by *Amateur Photographer* I have seen thousands of portraits which would have been really good but for one or more easily avoided errors and it is my earnest hope that this book will help all beginners and even some advanced photographers to avoid them in the future.

Technical perfection is easily acquired with the aid of modern apparatus and materials but after that it is the imagination and creative ability of the photographer that counts. These are applied instinctively by some people but in others they have to be drawn out by following guidelines such as those given in this book.

A few successful portraits thus obtained will inevitably kindle in some people a desire to progress to more sophisticated work so, where appropriate, I have recommended books for further reading.

R. H. Mason
January, 1977

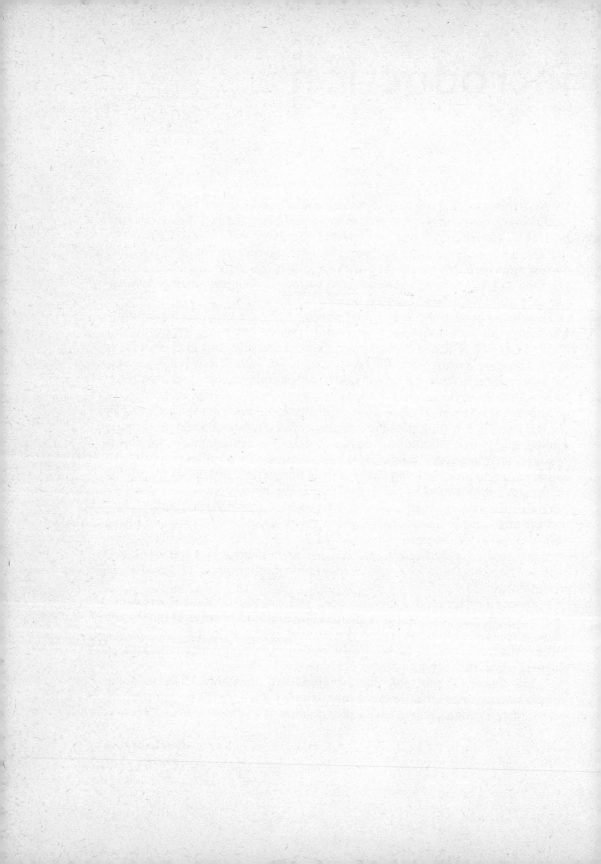

1 : The Apparatus

Cameras—lenses—tripods—exposure meters

PORTRAITURE, both indoors and outdoors, can be done with simple fixed-lens cameras but a camera with the facility for changing to a longer focus lens will be essential for serious close-up work. If the camera has to be taken close to the subject in order to fill the negative or transparency there will inevitably be some unflattering perspective distortion in the resulting picture.

A fixed-lens camera can be safely used for full-length portraits and when working in black and white one can, of course, operate from a distance which will provide good perspective, and then enlarge just part of the negative for a head and shoulders portrait. This is often satisfactory when using a 6×6cm camera and a medium-speed, fine-grain film, but there is always the risk of grain and loss of definition if the same device is employed with 35mm film or smaller. It will certainly be essential to use a fine-grain, slow- or medium-speed film and this in itself can create a problem with moving subjects or in poor lighting conditions.

For transparencies it is necessary to fill the whole frame in the camera because an enlargement from part of a transparency is normally possible only by making an intermediate colour negative. This is a costly process and there is inevitably some loss of quality.

Fixed-lens cameras have a lens with a focal length that is roughly equivalent to the diagonal of the negative or, in some cases, slightly less. It is the focal length of the lens which controls the angle of view and therefore the amount of scene included at a given distance. On most 35mm cameras the lens is around 50mm focal length which is useful for most general purposes but to fill the negative with a head-and-shoulder subject it would mean approaching to a distance of less than 4ft from the nose. This will not only produce a grossly distorted face and an enlarged nose, it will also frighten the sitter or at least make him or her self-conscious. It can also present difficulties in the placing of lights for indoor portraiture as we shall see later.

The equivalent focal length of lens on a 6×6cm camera is about 80mm and the camera would have to be taken to the same point as with a 50mm lens on a 35mm camera in order to take in the same amount of scene and fill the negative with it. From all this and for other reasons which will be seen

9

later in this book it is obvious that a camera with interchangeable lenses is almost essential for portraiture and in any case it is an advantage for other types of photography as well.

If the camera is required only for portraiture money can be saved by buying just the camera body and a long focus or telephoto lens, thus cutting out the cost of the standard lens normally supplied. Alternatively one might consider the Tele-Rolleiflex which is the only fixed-lens camera having a long-focus lens. However this is a roll film 6 × 6cm camera that costs a lot more than a good 35mm camera with three lenses and it cannot be focused closer than 8ft 6in, which may be a disadvantage in a small room if a full-length portrait is required.

Before purchasing a camera for home portraiture it is necessary to decide on the negative size. The 35mm is the smallest practical size for the purpose and 6 × 6cm is as large as anyone could want. There was a time when much larger sizes were employed, particularly by professionals, and they facilitated the elaborate retouching which was once fasionable, but few portraitists use a larger size than 6 × 6cm today although one model providing 6 × 7cm negatives is becoming popular.

The 35mm size is an advantage for transparency production because it goes into the 2 × 2in mounts which are popular and 2 × 2in projectors are much cheaper than 6 × 6cm. Modern colour negative and black-and-white films are so good that very big enlargements can be made without much loss of definition or the intrusion of graininess. Also, a 35mm negative is cheaper than a roll film negative and it is a convenience to be able to shoot 36 exposures without changing the film. Most roll film cameras take the 120 size which produces only twelve 6 × 6cm negatives although there are a few sophisticated models which use 220 film and yield 24 negatives 6 × 6cm.

However, there are many photographers who still prefer the larger size which undoubtedly has just that extra edge in definition that is desirable for exhibition enlargements or murals. They also maintain that 35mm users tend to get 'snaphappy' and do not give so much thought to each shot before pressing the release and this in the long run makes it more expensive.

The final choice of size is largely a personal one. Some people prefer the viewfinder with its built-in rangefinder that is found on most 35mm cameras while others prefer the large focusing screen, approximately the actual size of the negative, that is fitted to roll film cameras. Some may also be influenced by the fact that contact prints made from 6 × 6cm negatives are easier to examine and select for enlargement.

35mm cameras

Presuming that the choice falls on 35mm it will be found that there is a bewildering number of models available but those with interchangeable lenses are basically similar in principle, and they are known as single-lens reflexes (SLR). Differences in price are largely controlled by the degree of precision in manufacture and various extras in the specification. All have a mirror that

reflects the image formed by the lens on to a small focusing screen which is just below a pentaprism that directs the image to the eyepiece of the viewfinder. The shutter, which is usually of the focal plane type, is just in front of the film plane and at the moment of exposure the mirror lifts up and allows the image to go through to the film instead of the focusing screen. After exposure the mirror returns to its 45° position, and all this only takes a fraction of a second.

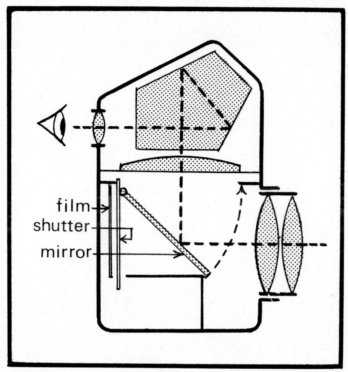

film
shutter
mirror

1 *Diagrammatic cross-section of a single-lens reflex camera showing how the image formed by the lens is directed to the viewfinder eyepiece via a mirror, screen and pentaprism. When the mirror is raised the image is directed unobstructed to the film plane.*

All but the very cheapest models have a rangefinder built-in and this is a convenience although by no means essential. The two main types are split image and microprism and the choice between these is very much a personal one. Neither of them work so well with long-focus lenses as with the standard lens but the microprism is probably the easier to use for portraiture. The split image type depends on having a straight line in the subject to be really precise and these are not found in the face. In both cases the rangefinder is only a small circle in the centre of the screen and the principal point of focus, usually the sitter's eye, is rarely in the centre of the picture.

The more expensive models have a built-in exposure meter which is also a convenience but it has to be used with discretion for indoor work. It can

be very deceptive in some circumstances as will be seen in Chapter 7. These cameras are sometimes described as TTL (through-the-lens) models.

All modern cameras are synchronized for flash but the cheaper models are only usable with a flashbulb or electronic flashgun actually on the camera. This is useless for portraiture by flash unless a slave unit is employed (see Chapter 4), so it is better to get a camera with outlet sockets that enable a separate flashgun to be fired at a distance from the camera.

Other refinements are largely confined to such things as interchangeable viewing screens, electronic shutters, very fast shutter speeds and larger aperture lenses. All of these are nice to have but by no means essential for portraiture. A delayed action mechanism is useful for self-portraiture and this will be found on most single-lens reflex cameras as well as those fitted with between-lens shutters.

An extremely useful but often neglected facility is a pre-view button. Nearly all SLR cameras view the scene at full aperture and only stop down to the chosen aperture when the shutter release is pressed. The pre-view button enables the user to see the effect at the selected aperture and thus judge the depth of field in focus. In other words the sitter may appear sharp and the background out of focus in the viewfinder when an $f/3\cdot5$ lens is fitted but if the taking aperture is $f/8$ the resulting picture may show a sharp background. Since this is normally undesirable it is useful to be able to see the actual effect at $f/8$ before taking.

Roll film cameras

These come in two types—single-lens reflex and twin-lens reflex (TLR). The former are really enlarged versions of the 35mm single-lens reflexes and are made to take 120 or 220 roll film. In some cases they are fitted with focal-plane shutters so that a range of interchangeable lenses can be used, while others use lenses which are each fitted with a between-lens shutter. The film is held in a separate chamber that has a masking slide so that lenses can be changed without fogging the film and also so that the whole back can be removed before the film is fully exposed. It can thus be replaced with another back containing another film. This enables black-and-white shots and colour shots of the subject to be taken within a few seconds of each other. Such cameras, of which the Hasselblad is an example, are naturally very expensive but they are ideal for portraiture and a joy to use.

The twin-lens reflex is basically two cameras, one on top of the other, but the upper one is used as a viewer only while the lower is the actual taking camera. The viewing lens which has no shutter or iris diaphragm moves in tandem with the taking lens for focusing. An obvious disadvantage is that one cannot see the depth of picture in focus at the taking aperture. The leading example in this field is the Rolleiflex which does not have an interchangeable lens facility but is a fine precision camera. Another popular model is the Mamiyaflex which has a range of interchangeable lenses but, one has to buy a complete panel holding the taking lens with shutter as well as the viewing

12

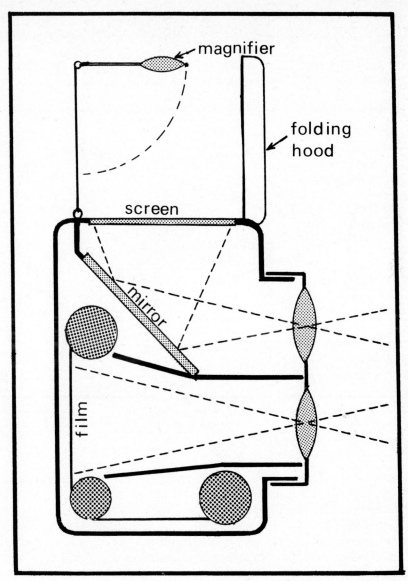

magnifier

folding
hood

screen

mirror

film

2 *Diagrammatic cross-section of a twin-lens reflex camera showing how the upper half provides a full-size viewing screen while the lower half actually takes the picture.*

lens, so it can be expensive if a number are required. However, for portraiture one, or at the most two, lenses should be enough.

One minor advantage of a TLR camera is that the screen does not black out during the moment of exposure and this can help in fast-action work but is not important in portraiture. The chief disadvantage is one of parallax. The taking lens does not cover exactly the same field of view as the viewing

lens so allowance must be made in the focusing screen or heads may be cut off. This danger is negligible for distant work but an important consideration in portraiture.

The chief advantage of roll film cameras is the large focusing screen which many people find helpful for composing the picture, and some are fitted with

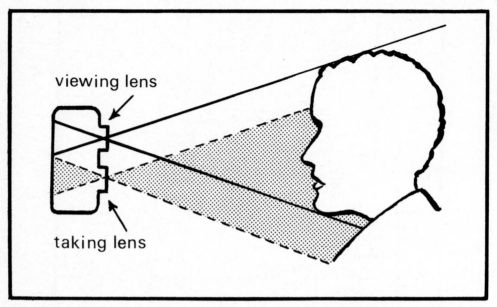

3 *Diagram showing how the view seen by the taking lens differs from that seen by the viewing lens. This is known as parallax and must be allowed for in close-ups except in cameras with automatic compensation.*

magnifiers to aid focusing. Exposure meters are not built-in but for most single-lens models an accessory meter can be clamped on to measure the focusing screen. This usually provides eye-level viewing as well.

To summarize briefly, a camera with an interchangeable lens facility is essential for portraiture and the single-lens reflex type is the most convenient whether 35mm or roll film. Smaller sizes are impractical and larger sizes are unnecessary for amateur work and, indeed, most professional work as well.

The lens

It is almost a statement of the obvious to say that the lens is the most important part of the camera. It must be capable of giving sharp definition at any aperture and it must be free from aberrations such as astigmatism, coma and spherical aberration which can produce distortions or soften the image. In particular, it should be free from chromatic aberration and capable of rendering all colours sharply. Most of these aberrations have been corrected in modern lenses by using a number of elements which compensate for or cancel out

14

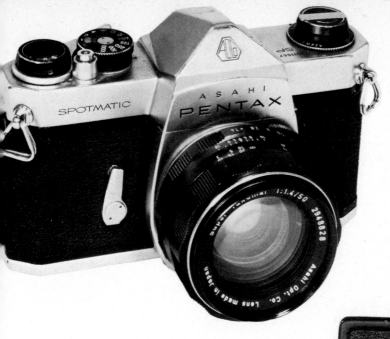

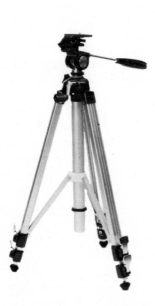

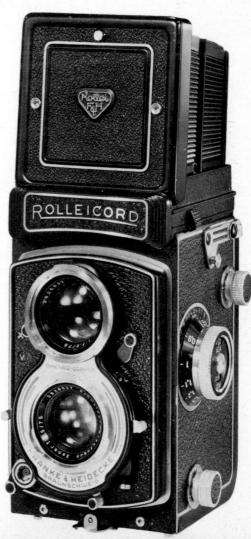

Fig. 1 *The two basic types of camera which are useful for home portraiture—the single-lens reflex and the twin-lens reflex. Also illustrated is an ideal tripod which has a universal pan-and-tilt head and struts to prevent the legs from spread-eagling.*

various defects. Modern lenses are truly wonderful compared with those of 100 years ago but good ones are necessarily expensive and it will pay to buy the best that the pocket will permit.

There are several categories and they are broadly described as wide angle, standard, long focus, telephoto and zoom. Wide angle lenses are those under 45mm in focal length on 35mm cameras and under about 70mm on 6×6cm cameras. They take in such a wide angle of view (anything from 50° to 120°) that the camera would have to be taken very close to fill the negative with a head and shoulders or even a half-length portrait. This makes wide-angle lenses quite unsuitable for portraiture unless deliberate caricature is intended.

Standard lenses, those of 45 or 50mm on 35mm cameras and about 80mm on 6×6cm cameras, have an angle of view of about 55° when focused on infinity and this is also inconvenient for anything but full-length portraiture because the camera would have to be taken so close that perspective distortion would result.

Long-focus lenses are anything from 90mm upwards on a 35mm camera and 135mm upwards on a 6×6cm camera. The focal length of any lens is merely an expression of the distance between the lens and the film plane when the rays from a distance object are in focus and it controls the linear size of the image. Thus the longer the focal length, the narrower the angle of view and the larger the image on the negative at any given distance.

For example, a very long focus lens such as a 200mm or more on a 35mm camera, is ideal for a number of purposes, notably sports and wildlife photography but it is too long for home portraiture because it would demand more distance between camera and subject than is available in the average house, or even in many gardens.

The best compromise is a 90mm or 105mm lens on a 35mm camera or a 135mm or 150mm on a roll film camera. If there is plenty of room a 135mm and 180mm respectively could be employed but they may prove to be a bit too long in the average sitting-room except for very close-up heads. Also the nearest distance on which such lenses can be focused is often too far for convenience in a small room.

A true long-focus lens is necessarily rather long because the extra distance between lens and film plane has to be incorporated in the mount due to the fact that modern cameras are not fitted with bellows, except in the case of some roll film models. This is not very important for portraiture because most of the work is done on a tripod but long-focus lenses are a little unwieldy for other purposes. The answer was found in the telephoto lens which is a compound lens having a negative back element and a positive front element enabling the lens-to-film distance to be considerably reduced without affecting the image size. Thus a 300mm telephoto lens may need only 150mm distance between lens and film but still give the same size image as a 300mm long-focus lens.

Zoom lenses have become very popular in recent years. At one time the definition was inferior to that of fixed focal length lenses but they have im-

proved so much in recent years that they merit serious consideration. The focal length can be varied on a zoom lens by rotating the mount and this, of course, alters the size of the image. It is very convenient for portraiture to have a zoom which varies from, say, 55mm to 135mm, because the focal length can be varied until the viewfinder shows exactly the desired amount of subject to be included on the negative without moving the camera and tripod. Zoom lenses are not easily available for roll film cameras but there is a great variety of ranges and makes for 35mm cameras. It is worth the extra cost to pay for one of the well-known brands or one made by the camera manufacturer because some of the lesser known cut-price models are not sharp throughout the range. All lenses, with the exception of cadioptric or mirror lenses have built-in iris diaphragms to control the amount of light entering the lens and also the depth of field in sharp focus.

Converters are adaptors which can be fitted between the camera and the lens in order to multiply the effective focal length of the lens by a factor of two or three. Thus a $2 \times$ converter used in conjunction with a 50mm lens will provide an image similar in size to that from a 100mm lens. Converters, sometimes called 'extenders', are a compromise when the cost of a long focus, telephoto or zoom is too high but there is inevitably a loss in definition. There is also a loss in light transmission and exposure has to be doubled for a $2 \times$ converter and trebled for a $3 \times$ converter.

Portrait attachments are single lenses which can be placed in front of the lens to give a larger image at any given distance. Except for the holiday snapshotter they are not to be recommended because they reintroduce aberrations which the lens maker has been at pains to eliminate; they are also difficult to focus and the definition leaves much to be desired except in the case of the very expensive sets sold for the quality twin-lens reflex cameras.

Accessories. For serious home portraiture a few accessories are required and there are others which are not essential but are useful or convenient. The first essential for formal portraiture indoors is a tripod and it must be a rigid one. The ideal type is one with a central pillar that can be wound up and down and that has struts between the legs which prevent it from collapsing through one leg sliding away on a slippery floor. Such tripods are not cheap but they will save money in the long run. A camera hitting the floor can cost far more to repair, and there is a great danger of wasting negatives through movement when a lightweight tripod is used. Some indeed are so aspen-like that it would be better to hold the camera in the hand.

There are occasions when there may not be room for a tripod or it may be too inconvenient to carry on location in someone else's house. A compromise can be found in one of the camera clamps that can be fixed to the back of a chair, a door or a mantelpiece. Here again a sturdy model with a large ball-and-socket joint and positive locking knobs is most desirable.

The tripod should have a good ball-and-socket head or a 'pan-and-tilt' head. Some models have one or the other as standard but they can also be bought separately and these should also be of sturdy construction. The cheap

models, of which there are many, are a false economy because the threads soon go and they are rarely free from wobble, the enemy of sharpness.

An absolute essential for any portrait work is a lens hood of adequate length to eliminate flare or reflections on the surface of the lens. Some long-focus and telephoto lens have a lens hood incorporated in the lens mount but this is not always convenient if filters or other attachments are used. There are several types of lens hoods, some metal, some rubber, that either screw in or slip on. Screw-in types are less likely to fall off but the principal requirement of any hood is that it should be absolutely dead matt-black inside so that it does not reflect any light on to the lens. A cardboard tube painted black with Indian ink is just as functionally efficient as any other.

Another essential when the camera is used on a tripod is a cable release. It should be at least 12in long in order to avoid any danger of jogging the camera when the button is pressed but many people prefer a much longer one so that they are free to walk around the camera. They can then talk freely to the subject and even, if necessary, make final adjustments to dress or lighting.

Exposure meters as already mentioned are often built-in to the camera so that they measure the light actually passed by the lens. This is a convenience but not always ideal because they measure an average of the light seen on the focusing screen. If the subject is very small and light against a dark background it is obvious that an average reading will cause the light parts to be over-exposed, while a dark and small subject against a white background will be under-exposed if the meter is faithfully followed.

Some cameras have 'centre-weighted' exposure metering which gives preference to the centre part of the screen and this partly overcomes the problem. Nevertheless the only way of getting a really accurate reading is to take the meter close enough for it to read only the subject and to be uninfluenced by the background. This is not very convenient when the meter is in the camera because it means removing if from the tripod and poking it almost into the sitter's face.

Sooner or later, therefore, the serious portraitist will feel the need for a separate meter although it must be said that some experienced workers are able to manage with a built-in meter by adjusting the given reading up or down on pure judgement. Separate meters are of two basic types—selenium cell and cadmium sulphide (CdS). The latter, which requires a small battery to activate it, is more sensitive and has a quicker response but the selenium cell type has a better over-all response to all colours. Nevertheless there is little to choose between them and there is an enormous variety available at prices from a few pounds upwards. Colour photographers should always choose a model that allows readings to be taken by incident light, i.e. the light source, as well as by the more common method of reading the reflected light from the subject.

One other type of meter is called a 'spotmeter' and it can be extremely useful to the portrait worker in colour. Most selenium and CdS meters have

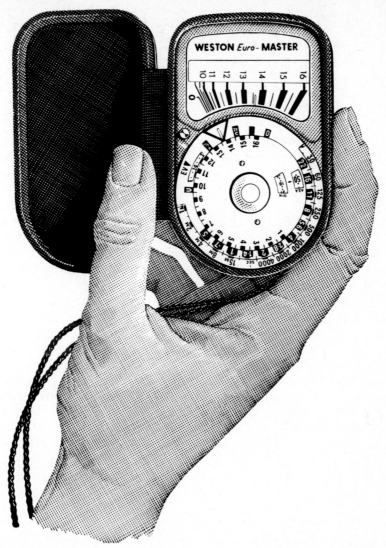

4 *A separate exposure meter is a great convenience for portraiture, especially in colour, and it makes for greater accuracy than a meter built-in to the camera. The latter is fine for average subjects but misleading under other lighting conditions.*

an angle of view of about 50°–60° which corresponds roughly to that of a standard lens. A spotmeter has a reception angle of only about 1° which makes it possible from the camera position to take separate readings of the highlights and the shadows on the face and thereby calculate the exact degree of contrast as well as to decide upon the exposure.

So much for the basic camera equipment for home portraiture. The next consideration is the film to use.

2: Choosing a Film

Black and white or colour?—colour negative or colour reversal?—sensitivity —tone translation—colour balance

AT AN early stage the home portraitist must decide whether he wants to work in black and white or colour or both. For the beginner, at least, it is not wise to attempt both at the same sitting because there is such a difference in approach and techniques. Many people today start with colour and never do anything else but they are missing a lot. Apart from the fact that black-and-white work provides an admirable grounding in technique, design and composition which will make colour work easier, it gives much more scope to the creative man.

Although colour materials and processes have made sensational advances in recent years, the black-and-white process is capable of much greater manipulation and modification. Just as etching is still popular in spite of oil painting, so there will always be a place for monochrome photography and especially in portraiture where colour can sometimes destroy character or not provide the opportunity to emphasize it.

The range of films of all speeds and makes in black and white and colour is enormous but it is advisable to make a choice and stick to it so that its characteristics and behaviour become familiar. Changing from one to another is only of benefit to the manufacturers.

Black-and-white films

There are two basic types: those which produce a *negative* from which unlimited prints can be made and *diapositive films* which when processed, provide a positive transparency in black and white and from which prints can only be produced by making an intermediate negative. Diapositive films are very useful for educational and commercial purposes but are not generally appropriate for portraiture.

When choosing a normal black-and-white film two characteristics must be considered—speed and colour rendering. Speed is a vernacular term for sensitivity and there are a number of systems by which it is measured but the most popular is that of the American Standards Association, called ASA for short. This gives an arithmetical progression which is very easy to follow. For example, a film marked 100 ASA is twice as sensitive as one marked

50 ASA and only half as 'fast' as one marked 200 ASA. In practical terms this means doubling or halving the exposure by opening up or closing down by one stop or, alternatively, halving or doubling the shutter speed.

The ASA speeds are marked on all film cartons and on some a DIN number is also given. This is the Deutsche Industrie Norm and is a logarithmic system. In the USSR there is a GOST system but only films made in that or in satellite countries are so marked. Some older exposure meters are marked in an earlier but now little used system called Scheiner and for the benefit of those with such a meter a conversion scale is given below.

ASA	DIN	SCHEINER	GOST
10	11	22	9
25	15	26	22
32	16	27	28
50	18	29	45
64	19	30	56
100	21	32	90
125	22	33	110
200	24	35	180
400	27	38	360
800	30	41	720

These systems are based on different parameters so they are not strictly comparable or convertible but the figures shown are good enough for practical purposes.

It should be noted that early Weston exposure meters are marked with what was known as the Weston system. From the Model IV onwards they have used ASA and DIN but the early models can still be used by reckoning Weston speeds as about two-thirds ASA speeds.

Black-and-white films are divided into three broad categories—slow, medium and fast. The slow films, 25–100 ASA, can be ignored for portraiture. They have many uses but the required exposures would be inconveniently long, especially indoors. Medium-speed films are those from approximately 125 ASA to 200 ASA and fast films are from 400 ASA upwards.

One is tempted to ask 'why not fast films for everything?' The answer is that the extra speed entails a loss of other qualities, notably grain and accurate colour rendering. The presence of grain, which is an agglomeration of crystals in the emulsion that occurs during development, is not a serious consideration for users of roll film but it is important to the 35mm worker because of the substantial degree of enlargement likely to be required. Grain in fast films can be reduced by using special fine-grain developers but these often entail a loss of speed, thus partly cancelling out the film's main advantage. Also, grain is emphasized by over-exposure and by over-development.

Over-exposure is, in fact, a very common fault among beginners in portraiture, far more so than under-exposure, and fast films encourage it. Sometimes over-exposure is not even recognized because the so-called latitude of the film ensures a printable negative, but it can never produce the same quality of print as a correctly exposed example.

The second, and more cogent, reason for using a medium-speed film in preference to a fast one is that of colour rendering. Black-and-white films do not translate colours into tones exactly as we would like to see them. At one time films were only sensitive to blue light which meant that other colours came out as black or dark grey and of course they were extremely slow. Later they were sensitized by means of dyes to take in more of the spectrum and these films were called orthochromatic. However, they were still over-sensitive to blue and not sensitive enough to red in some cases.

As it happens they were just right for portraitists in those days. The high sensitivity to blue meant that exposures could be shortened when carbon-arc lighting or north daylight was used in the studio because both have a high content of blue rays. Also, blue eyes came out as a light grey and flesh tones had plenty of modelling instead of being 'burnt out', due to the relatively low sensitivity to red.

However, the demand for most purposes to produce a film that was sensitive to all colours and translated them as near as possible into equivalent tones of black and white inevitably led to the introduction of panchromatic films which are sensitive to red as well as the other colours in the visible spectrum. This, of course, meant a greater overall sensitivity and, as a result, shorter exposures.

Panchromatic films vary in their colour response or balance. The medium-speed films, such as Ilford FP4 and Kodak Plus X are probably the most accurate while the faster films gain a lot of their extra speed through an over-sensitivity to orange and red. For this reason the latter are not ideal for portraiture because lips tend to come out too light and blue eyes too dark. This can be corrected by using a pale blue filter but it will mean an increase in exposure and the advantage of speed is largely lost. It could be restored by using a speed-increasing developer but this will probably encourage grain and may even lose some gradation. For all these reasons the home portraitist in black and white would be wise to choose a medium-speed film and use the recommended developer. In the case of FP4 this means IDII developer and for Plus X, Kodak's D76 developer. Of course there are many proprietary developers put out by other companies that are quite suitable. The important thing is to find the right film/developer combination to suit personal taste and conditions, and then stay faithful to it so that its behaviour is thoroughly understood.

Colour films

The portraitist who wishes to work in colour has to make a choice between colour negative film and colour reversal film. Colour negative film produces

a negative in complementary colours from which colour prints can be made. It is also possible to make satisfactory black-and-white prints. Colour reversal films produce by direct development a colour transparency. This is called a 'diapositive' in some countries, but this description can also include black-and-white transparencies. Colour prints can be made from transparencies by making an intermediate colour negative but this of course entails more time and cost as well as an inevitable loss of quality. Colour papers can be reversal processed but the quality is not very satisfactory.

A new process called Cibachrome-A has just become available and it enables the amateur to make excellent colour prints direct from transparencies with only three solutions. It has far more latitude in temperature control and filtration so it is much quicker and easier to use. A print takes about 12 minutes to process. Colour negative films have 'color' in the name, e.g. Agfacolor, Kodacolor, while most reversal films end in 'chrome', e.g. Kodachrome, Fujichrome, etc.

Colour negative film. Most colour negative films made by the leading manufacturers are between 64 ASA and 100 ASA. In all of them the colours of the original scene appear in complementary colours. For example, blue appears as minus blue, which is yellow; green as minus green, which is magenta; and red as minus red, which is cyan. Unfortunately it is difficult to assess the colour quality of colour negatives because they have an overall yellow or orange cast due to 'masking' which is a dye incorporated to overcome the imperfections of the other dyes that absorb some of the colours they should transmit. However, they have quite a lot of latitude in exposure, not quite so much as black-and-white films but more than reversal films, and a considerable amount of colour correction by the use of filters can be done during printing.

All colour negative films can be processed by the user although it is a time consuming and expensive process unless there are at least six films to develop within a short period. This is because the chemicals, once mixed, have a very short life. For this reason, many users prefer to let a dealer or chemist do the developing, even though it may mean waiting some days for the results. A dealer can also provide machine-made 'enprints' which are small enlargements that can provide a useful guide as to which negatives are, or are not, worth further enlargement.

Many people prefer to make black-and-white prints for selection purposes. These are easily made through the enlarger but the use of ordinary bromide paper will produce rather distorted colour translation. Special papers such as Kodak Panalure show better tone values but, being colour sensitive, they have to be exposed and developed in almost total darkness. Nevertheless it is an economical way of assessing portrait colour negatives for expression, sharpness and composition.

Colour reversal films. The disadvantage of these films is that they can be viewed only by transmitted light so a magnifying viewer or a projector is almost essential. This is obviously not ideal for portraits to frame for the

23

top of the piano but they are very suitable for reproduction in magazines or in other printed matter. Most printers prefer transparencies to prints.

The more popular transparency films have to be returned to the manufacturer for processing and the cost of this is included in the purchase price. However there are some, notably the Kodak Ektachrome range, which can be processed by the user but, here again, it is not economical unless there are a number to be developed within a reasonable period because the chemicals, once mixed, do not keep well.

The popular makes like Kodachrome 25 and 64, Agfachrome 100 and Fujichrome are comparatively slow, being between 25 ASA and 100 ASA, but the Ektachrome range provides higher speeds—up to 164 ASA—albeit with a slight loss of quality and the introduction of a little grain. All reversal films are much more critical in exposure requirement and have far less latitude because the densities should be constant and little or no compensation for exposure or colour balance can be made in processing.

Since the colour balance of reversal films cannot be altered in processing the manufacturers balance them for specific colour temperatures. They are sold in three categories: Daylight, Type A and Type B. The Daylight type is balanced for a colour temperature roughly equivalent to noon daylight on a slightly overcast day. Colour temperature is measured in degrees Kelvin and Daylight film is about 5500K. Type A film is balanced for use with overrun lamps called photofloods which burn at about 3400K, while Type B is intended for professional studios using tungsten lamps that burn at a temperature of about 3200K. It is not generally available in miniature size films.

The home portraitist who wishes to produce transparencies would have to use the Daylight type in the garden or with flash indoors; but the Type A film must be used indoors if he elects to employ photofloods. Daylight type film could be used with photofloods by correcting the light temperature with a filter such as the Wratten 80B, but this involves a big speed loss and the quality is not satisfactory. If it is necessary to stick to one film for both purposes it is better to use Type A and then employ a filter such as the Wratten 85 for outdoor shots. The quality is better and there is not such a great speed loss; in some cases none at all because the Type A film is faster than the daylight type.

It will be seen from this that it is not possible to mix lighting of different temperatures. For example, if the sitter in an indoor portrait is lit by photofloods an uncurtained window in the picture would come out far too blue and in fact would produce a blue cast on any part of the subject that received light from the window.

All in all, transparency films are not really suitable for portraiture unless facilities are available for Cibachrome prints to be made from them, or unless the sole objective is magazine or commercial reproduction. Even then, the disadvantages of slow film speeds and limited latitude may make negative film a better choice.

3: Indoor Lighting Equipment

Photoflood lamps—stands and reflectors —distribution boards—flashbulbs and flashcubes—electronic flash—slave units —bounced flash reflectors

PORTRAITS can be taken outdoors without any auxiliary lighting equipment although there are times when flash or a reflector may be desirable for reducing contrast. Portraits indoors can be taken by daylight from a window but, here also, a reflector or flash may be required for the same reason. However, the big disadvantage of this is that one is limited to the hours of daylight and since the strength of the light changes constantly it is impossible to standardize exposures.

Existing house lighting is very rarely satisfactory. It is not mobile except for standard lamps or desk lamps, and these are not easily directed at the required angles. Also, the colour temperature of house lighting is too low for colour work and not strong enough to allow the short shutter speeds required.

One is left with a choice of photoflood or flash, both of which are satisfactory although each has certain disadvantages.

Photoflood lighting

This is the name given to over-run electric bulbs. They look like ordinary domestic lamps but being over-run they give a much brighter light, although for a much shorter time. The popular size, which is quite adequate for home portraiture, is the No. 1 photoflood. It plugs into an ordinary bayonet socket and it gives a light that is equivalent to about 275 watts. There is a larger bulb, the No. 2, which comes only with an ES cap, that gives a light output of about 500W.

The No. 1 is quite powerful enough for home use. It will burn for about 2–3 hours but will last much longer, up to 10 hours or more, if two of them are used in conjunction with a series/parallel switch or a two-way distribution board. They can then be used at half power for setting up and focusing,

switching to full power only for meter readings and making the actual exposure. Since they inevitably burn hotter than ordinary bulbs this saves the sitter a lot of discomfort and also reduces the rather frightening studio atmosphere that alarms the nervous sitter.

Photoflood bulbs could of course be employed in ordinary domestic fittings such as chandeliers, desk lamps or standard lamps but for serious portraiture such things are not flexible enough and do not allow the light to be directed very precisely. In addition there is a danger of fire if the bulbs should touch a parchment shade. The ideal arrangement is a stand which can be raised or lowered as required, and which is fitted with a reflector that can be adjusted for angle. There are many models on the market at different prices and most of them are collapsible so that they can be stored away when not in use and can be easily carried for location work.

For maximum efficiency the bulb needs a reflector and there are three types available. One is a highly polished deep metal bowl that causes the light to be directed in a fairly narrow beam, and it is sometimes ribbed to concentrate it even further. One type allows the bulb to be moved in and out in order to provide some adjustment to the width of the beam. This type of reflector is ideal for the main light that will be the principal means of 'drawing' the subject. It is the nearest approach to the professional's spotlight which relies on an optical system to give a very concentrated beam with sharp-edged shadows.

The second type is an all-purpose reflector which gives a wider coverage and is therefore not so useful in portraiture unless full lengths or groups are contemplated. The third type is often called a flood and it consists of a very

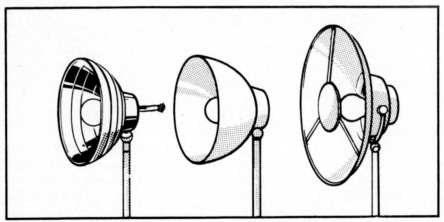

5 *The deep chromium-lined reflector on the left gives a hard and narrow beam and is the nearest thing to a spotlight that can be obtained without a lens. The one in the centre is shallower and matt aluminium. This is a good all-purpose reflector. The large shallow bowl on the right is painted matt white and the bulb is shielded. This gives a very diffused and shadowless spread so it is ideal for a fill-in light.*

shallow bowl painted matt white inside and having a mirror reflector suspended in front of the bulb so that no direct rays reach the subject. This is ideal for the fill-in light that is generally necessary to reduce contrast and put some light into the shadows. Used as near as possible to the camera/subject axis it will cast no shadows of its own on to the subject or the background.

The beginner will find that he can make a start with just two lamps, the deep bowl for the main light and the shallow white bowl for a fill-in light. However, more flexibility will be obtained with a third light for the background because it is often necessary to 'kill' shadows cast on it by the main light. Another deep bowl reflector is suitable for this because it can be adjusted to give a fairly even coverage or, by taking it in close, to give a halo or spotlight effect. Variation in the background tone is usually more attractive than an even tone throughout.

Instead of a third lamp fitting, some portraitists prefer to use a naked bulb on a stand which is adjustable for height. This has the advantage of giving a soft-edged halo effect on the background and also providing, under some circumstances, rim lighting or back lighting on the hair and shoulders. It is of course, arranged so that the sitter comes between the lamp and the camera.

There are a number of different types of folding stands to take the reflectors and the best of them are fitted with a ball-and-socket head or one that is adjustable for angle. The important thing is that they should be rigid and not top heavy when erected. One type of stand has provision for accepting flashguns and umbrellas as well as photoflood reflectors and these can be used for either form of lighting. This is especially useful when using flash for portraiture because photofloods can act as pilot lights for focusing and for checking modelling angle.

In addition to stands, reflectors can also be obtained attached to a strong spring clip which permits fixing to a door, chair back or mantelpiece. A ball and socket is fitted so that the lamp can be angled as required. This type of lighting unit is useful in very confined spaces or on location. Metal reflectors on these and on ordinary stands can get very hot so the better models which have a handle for adjusting the angle will save burnt fingers and make for smoother working.

It should be mentioned that there is another type of photoflood bulb which has a built-in mirror reflector so that no metal reflector is required. This is useful in emergencies where a proper reflector is not available but the type and width of the beam is fixed and some light escapes around the sides. Mirror bulbs are considerably more expensive than ordinary photofloods.

Another form of artificial lighting is the ciné-light or movie-light which is usually a quartz-halogen lamp and reflector giving a light that may be as powerful as 2000 watt. Unfortunately it is designed for short bursts of light and the continuous burning that would be required for posing and focusing in still portraiture will shorten its life and generate considerable heat. The colour temperature is inclined to vary with different makes and is not always right for Type A colour film.

27

The stands which are available from photo dealers usually have very short leads and this can be dangerous because it is so easy to trip over one that is stretched at an angle. They can, of course, be lengthened easily but a more satisfactory solution is to purchase a lighting control unit which has three or more 13 amp outlets, each having an on-off switch and a half-power switch. The unit, or distribution board as it is often described, will have its own fuses and a lead of 10ft or more so that only one house power point is necessary.

The great advantage of a power control unit is that focusing and posing can be done with the lamps at half power. This is more comfortable for the sitter, prevents pin-point pupils, and prolongs the life of the lamps. It is

6 *'Barn doors' are easily made from stout black card and attached to the rim of the reflector with two-way clips. Each 'door' should be about 9in wide.*

hardly necessary to add that the unit can also be useful for other jobs around the house—for the slide projector, for a power drill, the vacuum cleaner or any electrical apparatus for which an extension is needed.

Another useful accessory is a double clip. It can be attached to the reflector by one end and the other holds a piece of black card which can be used to prevent extraneous light striking the camera lens or to darken part of the subject. Two of these shields can serve as the equivalent of the 'barn doors' used in professional studios. The clips will also hold other types of masks

or coloured gels and they permit an air gap between the lamp and the accessory, thus avoiding any damage from heat. A form of 'snoot' made by rolling some stiff black card into a cone can be easily devised for special effects and this can also be attached with double-ended clips to the rim of the reflector.

Another accessory which the photographer can make for himself is a reflector board. This can be a piece of plain hardboard painted white or, for

Home-made snoot

Home-made tube snoot

7 Home-made snoots which can be attached to photoflood reflectors with Bowen two-way clips enable the beam of light to be closely controlled for special effects.

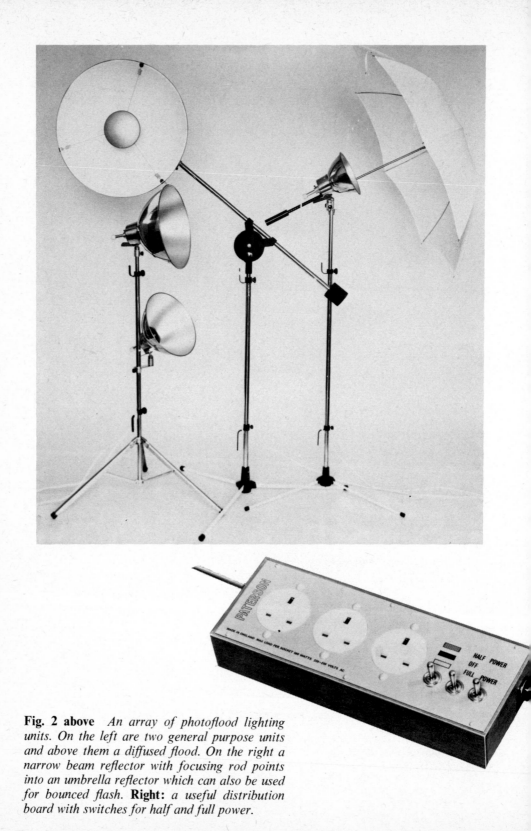

Fig. 2 above *An array of photoflood lighting units. On the left are two general purpose units and above them a diffused flood. On the right a narrow beam reflector with focusing rod points into an umbrella reflector which can also be used for bounced flash.* **Right:** *a useful distribution board with switches for half and full power.*

greater efficiency, it can be covered with kitchen foil. In a small room with light walls and ceiling this may serve as a fill-in light but it will demand a helper to hold it at the right angle. Alternatively a stand with a universal or ball-and-socket attachment can be made to hold it. A reflector board can be useful when placed on a sitter's lap or on the floor in front of him or her to reflect a little light into the shadows under the chin. Many people already possess a self-standing slide or film projector screen and this can often be made to serve as a reflector.

Flashlighting

Lighting by flash has become very popular in recent years because, for most people, the advantages outweigh the disadvantages. It is more compact and portable and does not involve a lot of trailing wires, especially if slave units are employed. It is cool and does not create the studio atmosphere that can upset a nervous sitter and make him or her self-conscious. The colour temperature of flash matches that of daylight type colour film so one does not need to buy a special Type A film or to use correction filters.

The principal disadvantage of flash is that one cannot see the precise effect of the lighting until the print is made. It may be thought that by standardizing the position of the flashgun or guns this can be easily overcome but unfortunately in close-up portraiture the slightest deviation can produce shadows in the wrong places or reflections in glasses if worn. This is not so important if bounced flash or very diffused flash is used but with direct flash at a sharp angle to the subject it can make all the difference between success and disaster. The solution is to use pilot lights as close as possible to the flashguns and directed at the same angle. The 'Interfit' stands already mentioned will permit this and the more sophisticated flash units have them built-in. The latter were originally designed for professional studios but there are some which have been so reduced in size and price as to be of interest to the amateur working at home.

There are two types of flash—flashbulbs and electronic flash. Flashbulbs only fire once and are therefore an expensive means of lighting except for those who take only a few pictures per year. They require a small holder containing a battery and capacitor circuit to fire them. Their only advantage is that they give a little more light than the average amateur electronic gun but since the latter is adequate for most purposes, this is not a serious consideration. Further disadvantages of flashbulbs are that they get extremely hot and are difficult to remove for some seconds after firing. Indeed it is the necessity for changing bulbs after every exposure that is probably the main disadvantage, especially if two or more are used. This is alleviated slightly by using flashcubes which are really four bulbs in one. They enable four flashes to be fired in fairly rapid sequence, especially if a gun which rotates them automatically is employed. When used in conjunction with cameras having focal-plane shutters the shutter speed must generally be limited to 1/25 second or longer and this may be very inconvenient if pilot lights are employed or

if there is much ambient room lighting. Electronic flash can be used up to 1/125 second with some modern focal-plane shutters and at any speed with between-lens shutters. For the sake of completeness it should be mentioned that there is a type of flashbulb called a 'Magicube' which looks like a flash-cube but is fired mechanically and not by an electric current. It only works on cameras especially made for it and since it has to be used on the camera it is not suitable for portrait work.

Modern electronic guns are compact, portable and very efficient. Some are 'computerized' by means of a sensor which measures the amount of flash reflected from the subject and quenches the tube when enough has been given for correct exposure. When the sensor is built into the gun it is not practical for portraiture because it means that the flash must be used direct and on or near the camera; both undesirable modes for portraiture. More versatility is provided by the latest models which have the sensing cell on an extension lead but the lead is not long enough for every type of lighting. However, an extension sensor does mean that the gun can be used in the automatic mode for bounced flash. All these guns have a manual 'over-ride' but for portrait work the ordinary and economical non-automatic electronic guns are as good as any. Obviously the more powerful the better.

Most flashguns incorporate a nickel-cadmium (NiCad) battery which can be charged from the mains and which will give anything from 80–200 flashes per charge. If they run down in the middle of a sitting it is no great problem because they can be fired direct from the mains supply. Other guns use ordinary replaceable batteries, usually two or four HP7 size, and this is handy for outdoor work but is much more expensive.

After each firing all flashguns take a few seconds to recharge and, when used direct from the mains, will take twice as long. This is no great disadvantage and is certainly quicker than changing flashbulbs. Nevertheless it is essential to wait until the 'ready-light' shows before making another exposure, or under-exposure will result. In some cases it may be necessary to wait a few seconds more because the light comes on before the capacitor is fully charged.

For portrait work, flashguns must be supported in the same way as photo-flood lights. Some have a built-in tilting bracket but, if not, a ball-and-socket head incorporating a flash shoe is required. The type of tripod attachment which has a universal head that will take an umbrella reflector and a flashgun is especially convenient.

Flash on the camera is never satisfactory because it is flat and casts unpleasant shadows. The main light required to produce good modelling must be away from the camera and at an angle to the subject, so an extension cable will be required if this is the only light to be used. Under certain cir-cumstances, as will be seen later, one light is sufficient if it is bounced from the wall, ceiling or an umbrella reflector.

Nevertheless, there is much more scope when a second gun is used for fill-in. This can be a much lower powered gun and it can be used on the camera flash shoe, from which position it will not cast any shadows to

32

conflict with those of the main light, especially if it is diffused with a layer or two of handkerchief or semi-transparent plastic. When such a gun is employed, the main light can be fired by a slave unit, thus removing the need for an extension cable which can so easily be forgotten until one walks into it and brings the camera and flashgun crashing to the floor.

A third flashgun for lighting the background separately can be useful although not essential and it will provide more control over the tone or colour. This gun can also be fired by a slave unit actuated from the flash on the camera. Slave units are now very compact, much cheaper than they used to be, and very reliable. A set-up of three flashguns and two slave units is all that is necessary for a very wide variety of portraits from high key to low key and romantic to dramatic. The firing is more positive than the cruder method of having extension cables which do not always make good contact, especially when connected to the 3mm socket on the camera via two- or three-way adaptors. If this latter method has to be used it is essential that the three guns have the same polarity or they will not fire and may even do damage to the camera.

However, three guns are not absolutely essential and many good pictures have been taken with two or even one. It means that the main light must be so placed that it does not cast a shadow on the background. It does not matter so much if the background is black because the cast shadow will be absorbed, but on a light background the lamp will either have to be so far around that the shadow misses the background, or the distance between sitter and background will have to be substantial. Either method restricts the scope available for lighting variations in a confined space.

Some people compromise by using two electronic guns—a main light and a fill-in—and then light the background separately with a photoflood bulb, with or without reflector. When the main light is bounced, the bulb's light will usually be strong enough to be effective and even kill shadows cast by the main light. Unfortunately the effect cannot be judged accurately and it is only after some experience and examination of the results that it becomes practicable. If colour is used it must be remembered that photoflood lighting is considerably warmer than flash so the colour of the background, lit by the former, will not be accurate; for example a blue background may well come out mauve or even green. Sometimes this is an advantage rather than a disadvantage!

If the fill-in light is placed on the camera it does not require an extension cable except for the short lead to the 3mm flash socket on the camera. Where there are two sockets, one marked X and the other FP, the cable should be inserted into X when electronic flash is used. The FP socket is for the special focal-plane flashbulb which is not really suitable for home portrait purposes and which is more expensive than ordinary flashbulbs or flashcubes. When the camera has a flash shoe fitted with contacts and the gun also has a 'hot shoe' no cable at all is required.

The type of gun used for fill-in may be too powerful in relation to the

33

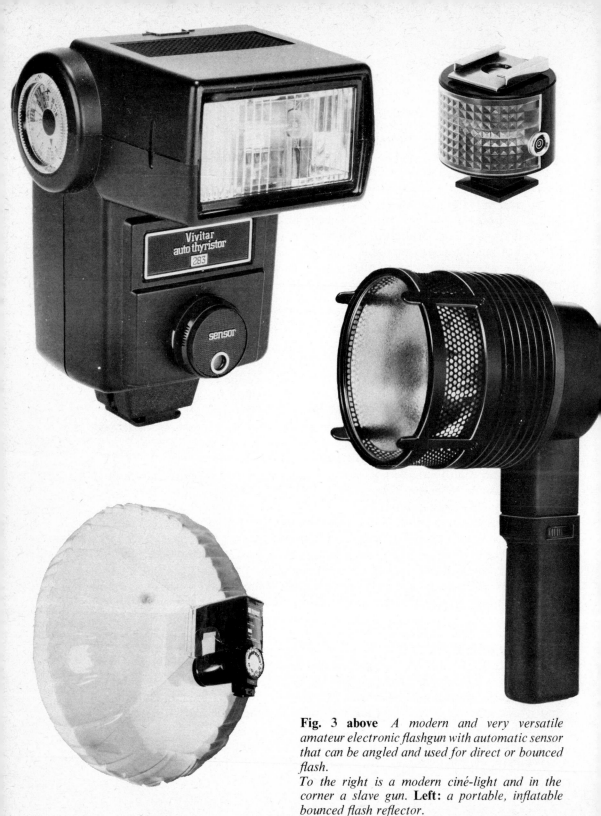

Fig. 3 above *A modern and very versatile amateur electronic flashgun with automatic sensor that can be angled and used for direct or bounced flash.*
To the right is a modern ciné-light and in the corner a slave gun. **Left:** *a portable, inflatable bounced flash reflector.*

main light. Rather than remove it from the camera, which would mean fitting an extension cable to take it farther back, the power can be reduced. White linen handkerchiefs can be placed over the gun for this purpose and each layer will cut the light output by about one-half. A more elegant method would be to make covers of semi-translucent acetate that can be clipped on when required. Both this and the handkerchief will have the additional advantage of diffusing the light still further and thus ensuring that there will be no cross shadows.

A handyman could make up a number of acetate covers in various colours to fit the main light, fill-in light and background light. This provides the facility for the multi-coloured 'gimmick' pictures that one often sees in exhibitions and the photographic press. Likewise, stiff acetate sheets of different colours and about 8in or 9in in diameter can be fixed in front of photoflood reflectors by means of double-ended clips.

It is just as important with flash as with photoflood to ensure that no strong light rays strike the lens direct, or flare will result. The barn doors recommended for photoflood lighting are not so practical with flash but fortunately the tube of an electronic flashgun is well recessed into its reflector. Nevertheless it is a good idea to have a few pieces of black card about 10×8 in handy if it is seen that there might be some spill. They can usually be clipped or taped to the side of the flashgun case.

Umbrella flash

There can be no doubt that a white umbrella or parasol provides the ideal reflector for a flashgun. In the early days, professional portraitists used them to soften the harshness of carbon arc lighting and the author of this book revived the idea as the answer to the harshness of flash in an article published in 1964. Since then many commercially made flash umbrellas have appeared on the market. Most are fitted with a shoe to take the flashgun and this is useful because it means that the light is always at a constant distance from the centre of the reflector, thus making exposure calculation easy (see Chapter 7).

They are available in white material, usually nylon, or opaque material having a silver or gold coloured lining and they fold up like umbrellas for portability or storage. Usually there is a screw socket for attachment to a tripod, as well as some sort of universal joint that enables the whole unit to be adjusted to any angle.

The silver-lined models do not allow any light to pass through them and they reflect back all the light from the gun if the latter is placed at the right distance to prevent light spill outside the umbrella. This makes them very efficient from an exposure point of view. The gold-lined models are also very efficient in this way and they have the additional advantage of 'warming' the light a little. This can be of benefit in colour portraiture.

However, the plain white type is more suitable for home portraiture. The very fact that it lets some of the light through is a good thing in a small

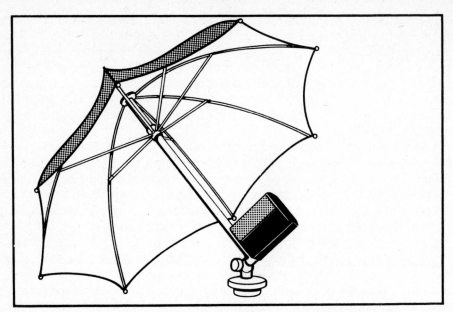

8 *A simplified version of an umbrella reflector which holds a flashgun in a shoe at its base. Combined with a ball-and-socket headed tripod this makes a versatile bounced flash unit that is often sufficient for home portraiture without any other lights. It may be white or lined with silver or gold metallic finish.*

room having light walls and ceiling. The transmitted light bounces all round the place, from surface to surface, and creates an ambient light which is a perfect fill-in for the shadows. It means that under some circumstances no other light, apart from one umbrella unit, is required.

Naturally, the exposures will be greater than with the opaque types at the same distance but apertures of f/5·6 or f/8 are possible with a reasonably powerful flashgun when medium-speed films are used. On balance therefore the beginner in portraiture who decides on flash would be wise to start with an umbrella reflector and as powerful a gun as he can afford. Practice with this unit alone will teach him a lot about the technique of modelling and lighting angles. Other units to provide greater versatility can be added later by which time the user will have learnt what else is required to achieve the precise effects he prefers.

4: The Background

**Sympathy with the subject—plain back-
grounds—tone variation—natural back-
grounds indoors—choice of colour—
backgrounds outdoors—sky as a back-
ground—variation by viewpoint**

THOUSANDS of otherwise excellent portraits are spoilt by a poor back-
ground. The most common fault is the inclusion of a background which
is obtrusive or fussy and thereby competes with the principal subject for
interest. An obvious example is patterned wallpaper and it is wise to avoid
this at all costs.

Another frequent fault lies in the use of a background that is not in
sympathy with the subject. In black and white this can occur when a dark
grey or black background is used for a delicate high-key subject such as
a baby or a blonde glamour girl or, conversely, when a white background
is used for a portrait of a dark-haired or dark-skinned man. In colour photo-
graphy it can result from choosing a hue which clashes with the colours of
the subject. For example red, which is an obtrusive and powerful colour,
would spoil the atmosphere of a baby portrait and probably clash with the
colour of the flesh.

When an existing natural background is used, this should also be in
harmony. An intelligent looking adult will probably look right against a
library wall full of books, but a lively young lad with an impudent expression
would not. The background should also match the clothing. A bride in the
kitchen, a parson in the bedroom or a bikini in the dining-room are perhaps
extreme examples of poor empathy but many lesser disharmonies are per-
petrated and the viewer realizes that something is not quite right without
actually being able to identify it.

Some people have tried using existing curtains as a background but this
also has disadvantages. The folds of the curtain will only appear parallel and
vertical if the camera is on a level and not tilted upwards or downwards to
the slightest degree. Sometimes when making prints it will be an improvement
to crop them so that the head tilts further forward or backwards, but this
would turn the folds of the curtains into diagonals which will look most
unnatural.

Plain backgrounds

On the whole the beginner would be wise to use plain backgrounds and to obtain interest in them by tone variations which can be easily achieved when a separate background light is used. The simplest possible background is plain white and this can be a wall painted white or a sheet hung from the picture rail. For very close up work even a slide screen may serve. With a white sheet it is possible to get a range of greys according to how much light is on the sitter and how far the sitter is in front of the screen.

If a near white background is required, as in high key pictures, it will almost certainly be necessary to have a separate background light, but if the sitter is several feet away and none of the main light is allowed to fall on the background a medium to dark grey is possible. This is where a 'barn door' is useful because it can shield light from the background without interfering with that falling on the subject.

For colour photography a white or grey background is undesirable. There should always be some colour in it and this can be obtained on a white background by using coloured gels over the background lights or flashgun. Alternatively, of course, a coloured wall or sheet can be used. This is more predictable because it is not easy, without some experience, to judge the depth of colour produced by gels, but, on the other hand, gels are obtainable in a great variety of colours and so give more scope than a single coloured sheet.

These gels, which are in acetate sheet form, can be held in front of the light units by means of Bowens two-way multi-clips which allow an air space so that the gels do not buckle with the heat.

With a white- or light-coloured background it is also possible to create tone variations by taking lamps in close so that a sort of halo effect is given around the sitter in the final print. Many people use a naked bulb on an adjustable stand behind the sitter to obtain this effect. It is also possible to vary the tone from top to bottom or from side to side by judicious use of the barn doors on an ordinary reflector lamp used for separate background lighting.

Nothing is more monotonous than a background which has the same tone or colour all over. The intensity of tone or hue can be varied according to the amount of light on it. A pastel colour can be made to appear much darker by reducing the strength of the background light or the distance between it and the sitter and, conversely, a dark colour background can be made to appear lighter by deliberate over-lighting in relation to the subject lighting.

Shadow patterns on the background are sometimes effective with appropriate subjects provided they are not overdone. They can be produced by arranging such things as a branch of leaves, a metal grille or a lobster pot in front of a concentrated background light in such a way that they cast a shadow out of focus and at an angle. It is also possible to use a slide projector for this purpose and to use slides made from an infinite variety of materials by binding them between cover glasses and projecting them out of focus. A powerful projector is needed, otherwise it may be necessary to reduce the strength of the main light to avoid killing the shadows cast on the background.

Fig. 4A *A dark background is appropriate when the lighting on the subject is low key or contrasty.*

B *A white background is not suitable for a dark subject—it looks like a cut-out.*

C *Even a high key picture needs a little tone in the background, preferably with some variation.*

D *A blonde subject is better shown against a light background like the one on the left.*

In general, backgrounds should have a matt surface so that they do not create highlights but an exception could be made in the case of a high-key glamour shot where the atmosphere will be enhanced by a satin background. Successful pictures have also been taken with crumpled Cellophane as a background. This gives more contrast and harsher highlights than satin so it complements full-tone lighting rather than high key. As well as having a matt finish the background for most purposes should be stretched taut and free from folds. A blanket or sheet which is hanging in swathes will provide unpleasant shadow patterns.

Those who have a large room available for portraiture will find special backgrounds employing rolls of paper an added advantage. There are several makes on the market and they consist of two expandable poles which can be erected in a few seconds between floor and ceiling while spring-loading keeps them firmly in place without damaging the plaster or carpet. A rotating cross-bar about 9ft long fits between the poles at any convenient height and this carries rolls of paper. Suitable paper of a tough, matt nature is available in a large range of colours and in black or white. This arrangement is a great advantage when taking full-length portraits or figure studies because the paper can be stretched over the floor in a wide curve and the lines caused by skirting boards or the joins between wall and floor are completely eliminated. Something of this sort is standard equipment in professional studios.

Advanced workers who like to outline the hair and shoulders with light so that the subject stands out well from the background find this arrangement very convenient. They can project one or two lamps from behind and above the background paper on to the back of the subject and achieve an effect similar to that seen on television in close-up interviews or in newscasts.

Natural backgrounds indoors

When it has been decided to show the subject in a natural environment, either at home or on location, special care must be taken to ensure that the sitter and everything about him or her is in sympathy with the background. For example, a priest in dog collar or robes would look fine in the vestry, the church or a library full of religious works, but he would look out of place in the kitchen. Likewise he would not be smoking or reading a comic. Even if he does these things in private life it would look out of character in a portrait and although this is an extreme example it shows the need to give some thought to the appropriateness of the background.

It is also important to avoid anything in the background which will create distracting highlights. Mirrors, glass-mounted pictures, wall lights, vases and windows are very easily overlooked when concentrating on the sitter's appearance through the viewfinder; but they can ruin the picture.

It is also desirable to keep the background as simple as possible, even to the point of removing unwanted items. A background full of different pieces of furniture, fittings or bric-à-brac draws too much attention to itself and can look very fussy. Putting it well out of focus offsets this to some extent but it

Fig. 5 *A background which is almost an even grey all over is a little monotonous, either in black and white or colour, even with a subject as attractive as this.*

Fig. 6 *With a high key subject a graded background from light grey at the top to near white at the bottom is appropriate and obtained by placing a lamp behind the subject.*

Fig. 7 *A nice 'halo' effect can be obtained by placing a lamp unit or a naked bulb behind the sitter's head and directed on to the background. This is better than shading during printing.*

is better to look around for the simplest background which complements the sitter and tells a story without dominating the picture.

When working in colour it is also important to bear in mind that 'hot' colours like yellow, orange and red can be very obtrusive so the cooler hues like dark brown, dark green and blue make better backgrounds and they help to make the sitter stand out. A study of good portrait paintings will emphasize the wisdom of this.

Naturally a colour must be chosen that does not clash with the colours of the sitter's clothing as well as the face. This is largely a matter of good taste but reference to a colour chart (see Chapter 11) will help. The colours should be complementary, i.e. from opposite sides of the chart, and it is better if the background colour is subdued or less saturated. In general, it is bad to put two colours together which are close to each other in the spectrum or colour wheel.

Unlike formal portraits with plain backgrounds, the natural setting should be evenly lit without hot spots or haloes. In other words it should look completely natural and not have the suggestion of a studio such as that given by graduated tone backgrounds. This means that the subject must be sufficiently far away to enable the background light to be at a distance which will provide even light all over. It is also essential to ensure that the direction of the lighting on the background is the same as that on the subject or the effect will be very unnatural.

In looking around for a natural domestic background it is desirable to ignore where possible anything which has vertical or horizontal lines. Bookshelves will force the user to keep the camera horizontal or they will not appear level and any possibility of changing the angle of the subject when enlarging is eliminated. Likewise, vertical lines such as doors or fireplaces may well prove an embarrassment when they appear to converge or lean over at perilous angles in the final print.

Large wall tapestries often make good backgrounds because the colours are usually mellow and unobtrusive. They should be kept slightly out of focus but not enough to blur the texture or design. At one time professional studios employed painted backgrounds depicting balustrades, pillars, scenery or just sky and clouds. Fortunately these have gone out of fashion and anything so artificial is no longer acceptable and should be avoided.

Backgrounds outdoors

As with indoor portraiture, the most common background error in pictures taken in the garden is fussiness. One of the worst examples is the use of a brick wall which, even when out of focus, provides a pattern of severe horizontal and vertical lines that are completely out of harmony with any portrait subject, except perhaps a bricklayer. Even then he would look wrong unless he was in working clothes with a trowel in one hand and cement in the other.

Likewise, the red or ochre of brickwork is too warm in hue and tends

to 'advance' in a colour photograph, thereby destroying some of the impression of depth. Also, these colours tend to clash with flesh colour, especially when the face is sun-tanned. Here again the severe lines present a problem if one wishes to tilt the camera or trim at an angle when enlarging in order to improve the subject presentation. A wall at an angle would look ridiculous.

If such backgrounds are unavoidable the bad effect can be minimized by choosing one that is in shadow while the subject is in the sun. It will then come out very dark and if it is kept well out of focus the result may be acceptable.

Another common background seen in portraits taken in the garden is that of a hedge or bush. The colour is usually suitable, especially if it is a dark or bluish green, but highlights which are caused by the sun or sky showing through tiny gaps produce a very spotty effect. True, these can be darkened in black-and-white printing, although this is a time-consuming nuisance, but in colour they are practically impossible to remove. The remedy is to choose a section of hedging which is thick enough to exclude all the light behind it.

It is also not uncommon to see garden portraits in which flowers are given too much prominence. It is better to eliminate them altogether by choosing a low enough viewpoint to cut out any ground behind the subject or to use the thick hedge already mentioned. Sometimes one sees a portrait which has a tree in the background that appears to be growing out of the subject's head. Likewise, the horizontal line formed by the top of a fence or hedge can occasionally be seen going in one ear and out of the other. It is always better to choose a viewpoint that avoids having a horizon line in the picture. The bright sky and the darker foreground always give the appearance of a picture divided into two parts. Likewise, make sure that nothing in the background is juxtaposed with the subject. A greenhouse sitting on top of the head or a rosebush growing out of a shoulder may cause a laugh when it was not intended.

Here again the pre-view button should not be neglected because it will show up extraneous objects like dustbins or deckchairs that were not obvious in the viewfinder at first because the eye has concentrated solely on the subject.

Simplicity is undoubtedly ideal and it is very easily achieved by using the sky if a plain, thick hedge is not available in the garden. It merely means using a viewpoint low enough to ensure that nothing but sky appears behind the subject or at least behind most of it. If any horizon *must* appear it should be very low in the picture but it can probably be avoided altogether if the subject stands on a box or a low wall. Unfortunately, the sky is not suitable if it is overcast and grey but a blue sky, with or without clouds, will look very good in colour and can be given tone in black and white by using a suitable filter (see Chapter 6).

Outdoor portraiture certainly should not be abandoned because the sky is overcast and the sun is not shining. As a matter of fact this is almost the ideal condition for colour portraits because the contrast is reduced to a ratio

Fig. 8A *This background is too fussy for a portrait and there are too many distracting elements.*

B *This is a little better because the sitter is more dominant but the blossoms are too light and too sharp.*

C *The background is out of focus but too light and too speckly so it draws attention from the face which is a little too dark.*

D *A fussy background as well as foreground has been rightly subdued by differential focusing and the face dominates.*

Fig. 9A above *When in doubt the sky can be used as a background and the low view-point necessary flatters this type of subject. A filter will be required to obtain tone in the sky for black-and-white photographs.*

B below *A tree in the garden makes a good prop but it is best to use a large aperture to keep the bark and the background well out of focus.*

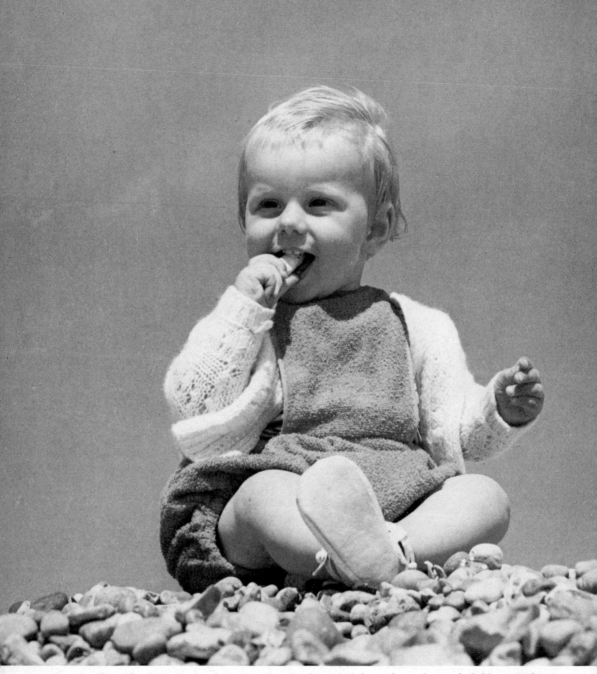

Fig. 10 *The sky makes a perfect background for colour shots of children. Indoors, variation of tone is desirable but outdoors an even tone all over is natural.*

which the film can fully encompass. However, a white or light grey sky is not an ideal background so one must resort to other means, such as a white or light coloured cement faced wall, a thick hedge or an attractive fence at the correct angle to the prevailing light. It must not be forgotten that even on the dullest day the light is still directional so the position of the subject will be controlled by it and the background is secondary.

Failing this, two options remain. It is possible to shoot downwards so that a lawn serves as an all over green background. This means climbing a ladder or finding some elevated position and asking the subject to look up towards the camera. On a bright day this may cause squinting but on an overcast day will probably be no problem. If the exposure is kept short enough to retain tone and detail in the face the grass will probably appear as a pleasing dark green. A high viewpoint should be used only for head and shoulder portraits because the rest of the body will be foreshortened and a six-footer will look like a five-footer with fairy feet.

The other option is to do what has already been described for indoor work. A sheet or blanket can be pinned up on a fence, wall, garden shed or greenhouse that is facing the right way for the light. Obviously this will result in a rather more formal background than the natural one and the pose, clothes and other details will have to be in keeping. Nevertheless, in the summer it is a quick and easy way of producing satisfactory portraits, especially in colour.

Whatever background is employed it should always be kept at least a little out of focus so that the subject stands out sharply against it. As it happens, this is a great advantage because it means using large apertures to ensure a small depth of field and this, of course, means short exposures to match. As a result a lot more subject movement can be tolerated than in most indoor portraiture by photoflood lighting and lively action pictures are made possible.

The secret of a good background can be summed up as simplicity, appropriateness and unobtrusiveness.

5: The Basic Principles of Lighting

The main light or key light—the fill-in light for contrast control—background lighting—effect lighting

THERE is a single fundamental principle for lighting any subject, indoors or outdoors, and it is that modelling and roundness can be obtained from one, and only one, source. A little thought shows that this is natural since the sun is virtually a point source and even when diffused by cloud it is still directional. In other words we are enabled to see the depth or shape of an object solely because of the light provided from a single source.

It is true that indoors we may have artificial light sources throwing light in a variety of directions but photographs taken by their light alone would look unnatural and we certainly would not have control over the drawing of the subject, apart from the technical problems involved. For all normal portraiture it is therefore wise to think in terms of one light source and any other lamps or units involved are employed solely to overcome technical problems or to provide special effects.

This one light source, usually called the main light, but sometimes described as a 'key light' or 'modelling light', should be deployed before any other and it is a mistake to switch on a battery of fill-in lights, rimlights, top lights and background lights until the position of the main light has been determined and an exposure meter reading taken from it. Even with flash this light must be placed in a position which will control the drawing of the subject and any other units or reflectors must be so arranged that the viewer of the subsequent print is not aware of them.

There are many positions at which the main light can be placed in relation to the subject and the one chosen must be right for the type of effect required. For example—if the light is on or near the camera/subject axis, or even on

ig. 11A *A narrow chromed reflector casts hard* *adows, especially when it is close to the subject.* *is generally more suitable for male portraits here texture is important.*

B *A diffused floodlight or bounced flash gives a soft light with good modelling but less defined shadows and it is flattering for female portraits.*

When contrast is reduced by filling hard adows too much like those in the picture above, ere is a considerable loss of modelling and the ace looks flat and too wide.

D *Bounced flash or diffused flood is not necessarily confined to high key or normally lit subjects. Low key like this is possible when the background is dark and there is no ambient reflection.*

the camera itself, the effect will be very flat and the head will lack roundness or modelling. There will be scarcely any nose shadow and the eye sockets will be as light as the cheeks or the ears, so the shape of four of the features will be lost. The print will not say whether the nose is big or small, the eye sockets shallow or deep and the chin receding or prominent. Inevitably much of the likeness will be lost and a round face will look like the moon.

Raising the main light will improve the effect by casting a shadow under the nose, eyebrows and chin, but this is still far from ideal because both sides of the head, if it is facing the camera, are evenly lit. It will be necessary to turn the head so that one side is partly in shadow or alternatively to move the light to one side while still keeping it above the subject level. For a full-face shot the best modelling will usually be obtained by placing the light about 30° to left or right and 30° above the subject. More dramatic modelling will be obtained by moving the light to about 45° round and above. This is good for bringing out texture and character so it is not flattering, but nevertheless it is suitable for most male portraits although care must be taken to ensure that the eyes themselves are not put into shadow and that a large nose is not accentuated by the length of its shadow.

Some instructors advocate a study of the nose shadow for determining the correct position of the main light. The theory is that when it falls at an angle of about 45° and just short of the upper lip it is about right for a character portrait but a shorter shadow at a lesser angle would be right for gentler or perhaps even high-key subjects. This can be a useful rule of thumb for an average subject but it only applies when the face is square on to the camera.

It is an illuminating exercise (in more ways than one!) to place a wig stand, bust or hairdresser's dummy on a table in a darkened room and then study the effect of a light placed at different angles to it. Start by placing the lamp directly in front and on a level with the head and the face will look very flat indeed. Move the light to an angle of about 30° but still on a level with the subject, then to 45°, 60°, 75°, and 90°. Repeat the operation with the light raised to 30° above the subject level and then to 45° above. Study the effect at each position, preferably through blue glass or sunglasses which will increase the apparent contrast, and if possible take a picture at each stage. The resulting prints will be a valuable reference for the future.

This is also a useful exercise to establish the distance at which the lamp is to be placed. If it is too near there is likely to be a noticeable difference between the lighting on the forehead and on the chin. It is undesirable that the forehead should be much lighter than the chin and a bald head will gain undue prominence. As a rough guide, a lamp at 30° above the subject should be at least 4ft 6in away and when the lamp is raised up to 45° the distance ought to be at least 5ft. If this is not possible a compromise must be reached by shading during printing. This can be done easily in black and white or colour printing but of course will not be possible with transparencies. Fortunately, in colour a lesser degree of contrast is tolerable because the colour itself contributes to the modelling of the subject, but in black-and-white work it must be created

by light and shade. Therefore, a lamp height of 30° is sufficient for most colour work.

It should be emphasized that these remarks apply whatever the nature of the light—spot, flood or flash, because the 'drawing' of the subject is solely a question of position.

Naturally, when a different pose is adopted and the head is turned to left or right it will be necessary to move the light to left or right to get the same effect. For example, if the sitter's face is at an angle of 45° to the camera the main light could be moved round to about 60° and for a profile or near-profile portrait the light could be as much as 75°.

It should, of course, be on the side that the sitter is facing because nothing could be worse than having brighter illumination on the back of the head than on the face. It is always better, when the head is turned, for the cheek on the far side of the face to receive more light than the side nearer to the camera rather than the other way round. The exercise suggested here will also demonstrate how the angle of the light affects texture rendering and therefore the character of the resulting picture. At 45° round and above, the light is casting shadows in every nook, cranny and furrow. This position is therefore ideal when a strong character rendering is required as for most men and also for old ladies where a sentimental mood is not appropriate. At the lesser angles more light gets into the crevices so it is flattering and therefore suitable for glamour pictures and children's portraiture.

However, this is a case where the nature of the light does make a difference. A spotlight or direct flash, both of which cast sharp and clearly defined shadows, will pick out every pore in the skin if it comes from an acute angle, but a diffused flood or bounced flash will give very much softer texture rendering. A photoflood in a deep reflector will give fairly sharp shadows although not so hard as a spotlight or direct flash as explained in Chapter 3.

It is worth repeating the suggested exercise with different types of light so that the results can again be studied and retained for future reference. Some lamps cast a 'hot spot' in the middle and this must also be taken into account.

It will be apparent that the degree of contrast should be decided in advance and it must be suitable for the subject. It is wise to get into the habit of visualizing the required final effect before starting on a portrait. If this is done the main light can be placed in position e en before the sitter arrives and then only very minor adjustments will be required. He or she will have much more confidence in the photographer who does this than in one who spends a long while experimenting with the light.

The fill-in light

When the main light has been positioned satisfactorily the fill-in light must be considered. This is the lamp which is a technical requirement to control contrast and it must not be allowed to affect the drawing of the main light in any way. It must be as near shadowless as possible and this demands the use of a shallow bowl reflector, preferably with the bulb masked, as described

51

Fig. 12A *The angle of the main light decides the modelling or shape of the subject. Here it is below the level of the sitter and directly in front. The result is unnatural and theatrical.*

B *Here the light is close to the lens and the result is extremely flat. This is a position which should never be employed for the main light but it is ideal for the fill-in light.*

C *The main light is in front of but well above the subject. This has provided some shadows and a semblance of shape but the all-important eyes are in shadow and the nose shadow is ugly.*

D *Here the light has been taken a little to one side, but on a level with the face. It gives a more accurate rendering and it can be seen that the head is actually more oval than the other pictures show.*

Fig. 13A *The light has now been moved a little farther so that it strikes the face at an angle of about 45°. This has narrowed the face still more but created an ugly nose shadow.*

B *The light is now at 90° although still on a level with the face. Even with a fill-in light this would look unnatural and would appear to divide the head in half.*

C *The main light is now at about 30° to one side and 30° above the subject. With adequate fill-in this position gives plastic modelling suitable for the average subject taken full face.*

D *More dramatic lighting and texture rendering is obtained with the main light at about 45° to one side and 45° above. This is suitable for most male portraits and character portrayals.*

in Chapter 3. Alternatively, if flash is employed for the main light the fill-in flash must be heavily diffused with layers of linen or bounced into a reflector.

It must also be placed in a position where it will not produce cast shadows because they would conflict with those cast by the main light and even produce extra dark patches where the two shadows cross. This means that the light must be as near as is practicable to the subject/camera axis. The distance of this light from the subject is the factor which affects the contrast ratio between shadow and highlight areas of the subject and its position on or near the camera/subject axis ensures that light falls on the shadow areas and reveals detail in them.

In order to judge the correct balance to obtain the required degree of contrast it is necessary to turn out all room lights if they are still on because they are naturally giving some illumination to the shadows. In fact it is advisable to turn them off even for placing the main light unless they are giving a very low level of light. By moving the fill-in light backwards and forwards along the camera/subject axis it is easy to see that a big range of contrast is available. It can range from shadows which are virtually black to shadows which are only a little darker than the highlights.

Unfortunately visual judgement is not completely reliable because the iris of the eye very quickly adapts itself when the gaze is transferred from highlight to shadow; but the camera cannot do this. What looks reasonably balanced to the human eye is liable to come out far too contrasty in the final result. Film can only accommodate a limited range of tones and printing paper still less. This can mean that if the contrast is not reduced to within the capacity of the materials a 'soot and whitewash' effect is probable. In other words, if the exposure is correct for the highlights the shadows will be black or lacking in detail and if exposure is read from the shadow areas the highlights will lack detail and be washed out. It would be tempting in such circumstances to take a reading from a middle tone but this would only mean having poor tone gradation in the highlights and insufficient detail in the shadows, so the total effect would be very flat.

In black-and-white photography the contrast of the lighting can be as much as 4:1 before it comes outside the limits that the print can reproduce when using popular films and papers. A very dramatic low-key picture in which a minimum of shadow detail is acceptable could even extend beyond this but in general it is wise to keep the range for monochrome between 2:1 and 5:1 according to the effect required. The former ratio would be right for a high-key picture and the latter for a dramatic character portrait in fairly low key.

In colour photography the range is more limited than in monochrome and a ratio of about 2:1 suits the average subject. As already explained, the colours themselves provide plane separation and modelling, but in black and white it must be achieved by tone variation alone. Since the flesh of a face is much the same tone all over a stronger lighting contrast than for colour is required to achieve good modelling.

54

Fig. 14A *Taken with a narrow beam reflector lamp giving hard shadows and no fill-in light at all. Exposure was based on the highlights so the shadow areas are completely black.*

B *The same arrangement except that a fill-in light was placed near the camera. This has put a little tone into the shadow areas and lightened the background slightly.*

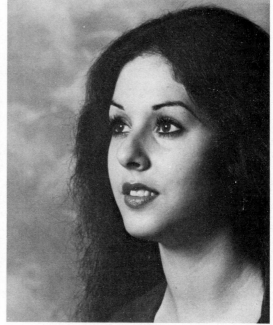

C *The fill-in light has been brought much closer to the subject although still on the camera/subject axis. The shadow areas now have a nice luminosity and the background is still lighter.*

D *A similar shot but using bounced flash as the main light. Its broad spread has illuminated the background and there was enough ambient reflection in a small room to provide shadow fill-in.*

When adjusting the distance of the fill-in light, it helps to view the scene through half-closed eyes or a piece of blue glass because this eliminates some of the detail and comes nearer to the extra contrast that the print will show. However, in the long run it is only experience that enables one to place it so as to achieve a precise effect. With the aid of a separate exposure meter it is possible to get close enough to the subject and take a reading from the highlights alone and another from the shadows alone. This is explained in detail in Chapter 7.

Further experiments with the dummy set-up suggested earlier would be valuable experience and if records of relative distances and exposures are kept it should be possible to duplicate any desired degree of contrast at any time. This is almost essential if flash is used because the effect cannot be judged visually.

It is obviously impossible to get the fill-in lamp exactly on the camera/subject axis, especially if a large bowl reflector is employed, and it is often placed just above or to one side. Contrary to what one might think, it is better to put it on the same side of the subject as the main light. In other words if the main light is on the left of the sitter the fill-in light should be just to the left of the camera/subject axis. Placing the light above the camera level is rarely satisfactory and it can be a nuisance. Far better to place it *below* the camera level, especially when the subject has deep-set eyes or is casting a lot of shadow under the chin.

Background lighting

Having settled the relative positions of the main light and fill-in light, the next most important consideration is the background. Sometimes in a small room there will not be enough room to light it separately so the main light will have to serve a dual purpose. However it is bound to cast a shadow on the background and this will look very ugly if it is included in the picture.

If the main light is at an angle of 45° or more and the background is at least a few feet behind the sitter the cast show may be out of the picture when only a close-up is being taken with very little background included around the subject. However, it would be a mistake if, after settling the position of the main light in order to get the required modelling, it was moved just to get rid of the cast shadow.

When a pure matt black background is employed the shadow will be absorbed but otherwise a compromise must be made in tone, angle of light and the distance between sitter and background. Here again some practical experiments with a dummy head will prove instructive and provide a useful reference for the particular circumstances.

Nevertheless, separate lighting is far more satisfactory and gives much greater scope for attractive tonal variations. A lot can be done with the naked bulb mentioned in Chapter 3. The bulb can be placed in a desk lamp or tablelamp fitting with the shade removed and placed between the sitter and the background so that it is shielded from the camera. By varying the

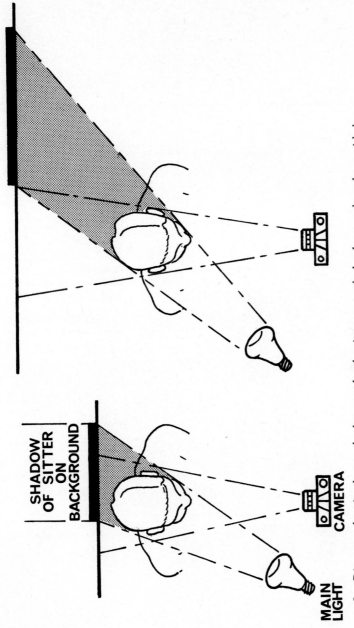

SHADOW OF SITTER ON BACKGROUND

CAMERA

MAIN LIGHT

9 Diagram showing how a shadow cast by the sitter on to the background can be avoided by keeping sufficient distance between them. This distance varies according to the angle of the main light.

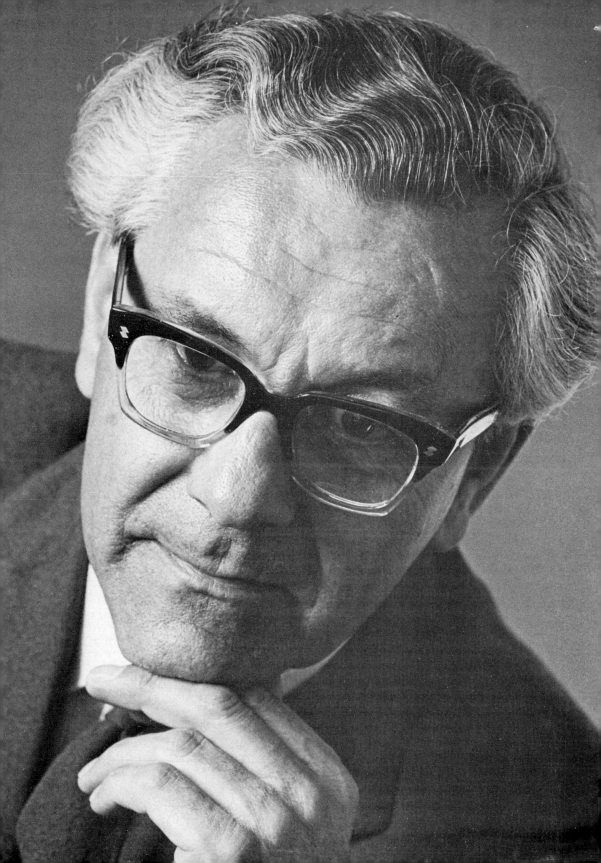

distance from the background it can be made to give a variety of halo effects from a very broad illumination to a near spotlight effect.

It will also throw a little light on to the underside of the hair at the back and sides and this can sometimes be attractive but, if this is not desired, the bulb must be shielded or be replaced by one of the mirror reflector types that can be directed on to the background alone.

The height of the bulb should be adjusted so that the halo appears well up in the picture and this may mean putting the lamp on a chair or stool. Care should be taken to ensure that the bulb does not come into contact with any material, especially if it is a photoflood which can get very hot.

It will be readily appreciated that this arrangement gives quite a lot of scope when a plain background is employed because bulbs are obtainable in a great variety from 40W up to the powerful 500W No. 2 photoflood and this fact, coupled with the possibility of using different tones or colours of cloth for the background makes possible an infinite control of tone values, even in a small room.

The more powerful bulbs can even have some effect when flash is employed for the main light and fill-in, especially when the flash is bounced, but of course the effect cannot be visualized and only experiment and experience can ensure a particular effect. When taking colour portraits by flash and using daylight type film, a bulb will give a much warmer or redder light so this must be taken into account. Too warm a background is not always desirable in portraiture because it will tend to advance (see Chapter 11).

If it is practicable to use a separate lamp unit for background lighting, one with a medium-depth reflector is the best. A large bowl reflector will have a wider coverage but in a small room it would be difficult to prevent some of the light from spilling on to the subject proper. Under some circumstances the medium-bowl types could do the same but they are easier to shield with a barn door as described in Chapter 3. It is also possible to add a snoot or tube to obtain a narrow, concentrated beam for a semi-spotlight effect.

This lamp should always be placed on the same side of the subject as the main light because it will be illuminating the background at an angle and the tone is bound to get darker on the farther side of the background. In a portrait which is anything but full face, it does not look right to have the lighter part of the background on the side of the head which is in shadow.

In the case of a full-face portrait the background should not be darker on one side than the other but it can be effectively graduated from light at the bottom to a darker tone at the top. This is easily achieved with the naked bulb or, alternatively, a third lamp unit placed low down and directed upwards on to the background.

In placing background lights it must be borne in mind that, as with the main lighting, it is difficult to judge the precise depth of tone that will appear

Fig. 15 *A portrait which shows that it is possible to get pin-sharp texture rendering even with bounced flash and it is only the angle that decides it.*

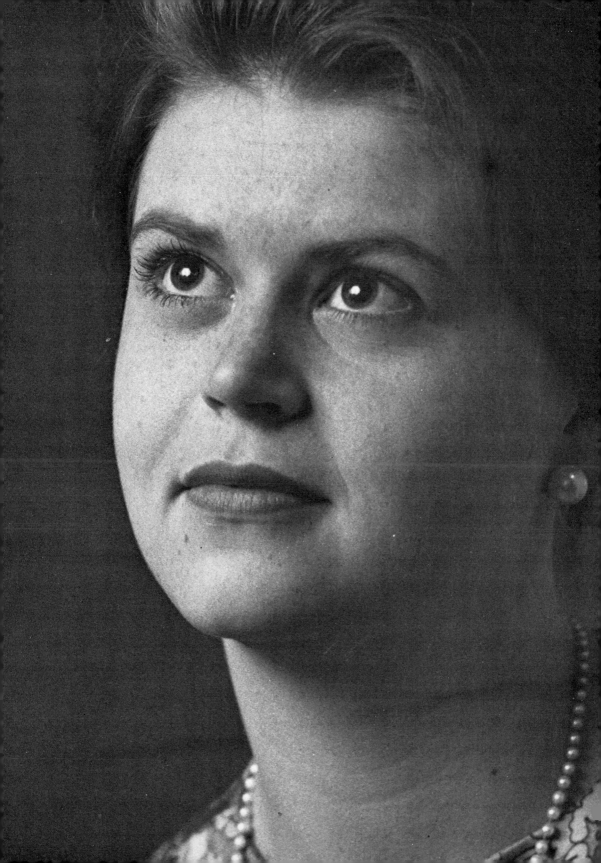

in the final result. It will always come out relatively darker than it appeared at the time because of the amazing adaptability of the eye when it is directed from subject to background. Viewing through blue glass or half-closed eyes is again a help but one soon acquires the ability to visualize the result if the same apparatus is always employed and records of the relevant dates are made on a series of experimental test prints.

Effect lighting

The only other lights that should ever be considered for portraiture are those designed to add a little sparkle but they are by no means necessary and they must not be allowed to intrude on the picture at the expense of the main light. The most commonly used effect light is a top light, rimlight or boom. It is employed above and just behind the sitter so that it puts some extra light into the hair and on to the shoulders. It can put some detail or sparkle into very dark hair that might otherwise come out as a black mass and it helps the subject to stand out from the background. Under no circumstances should the light be so strong that the highlights it creates dominate the resulting picture.

Rimlighting is employed universally in films and television because it ensures that the figures or heads will be well separated from the background even when they move about, but thousands of good still portraits are taken without such lights. Simplicity is a virtue in portraiture and sparkling patches of highlights are best kept for theatrical photography.

Fig. 16 *This portrait shows the converse of Fig. 15. Here a soft rendering and plastic modelling has been obtained with a narrow beam lamp by placing it at a shallow angle to, and only just above, the subject.*

61

6: Portraiture by Bounced Flash

The nature of the light—using ceilings and walls—umbrella flash—white, silver and gold reflectors—fill-in lighting —background lighting—self-portraits— babies and pets—mobile bounce flash

THE SAME principles of positioning photofloods for modelling and contrast control that were described in the last chapter apply to flash lighting. In the final result no more than one direction of light should be identifiable. Unfortunately it is impossible to judge the exact effect until a print has been made or a lot of experience gained. Professionals overcome this problem by employing flash units which have tungsten bulbs built into the reflectors so that they are in effect lighting by tungsten and exposing by flash.

These units are too bulky to be practical in a small home although the handyman could probably devise a means of fixing his flash units to photoflood reflectors. However this would be defeating two of the biggest advantages of flash which are the omission of trailing wires and the absence of a hot, bright studio atmosphere.

Another problem with flash if it is directed straight on to the subject is that it casts very hard shadows and brilliant highlights, so if the angle is not right a picture can be easily ruined. For instance, a sitter with spectacles may only have to move half an inch for glare to appear on the lenses or for the frames to cast shadows right across the eyes.

This problem is considerably eased if the flash is bounced from a reflecting surface. The light reaching the subject is so diffused that the shadows are considerably softened, contrast is reduced and the sharp falling off of light with distance that is so evident in 'flash-on-camera' shots is avoided. A small room at home can provide ideal conditions for bouncing flash because ceilings and walls are close enough to act as reflectors without too much loss of light.

When these are used the flash can be employed actually on the camera and no fill-in will be needed in normal circumstances, but the gun must have the facility for tilting it upwards or sideways. Naturally the reflecting ceilings

or walls must be white for colour portraits otherwise colour casts will appear on the subject. Even for black and white, light tone surfaces are very desirable or there may be too much absorption of light.

If the ceiling is used it is necessary to aim the flash at a point where most of the light will fall on the sitter and not be wasted behind him and this usually means a point much nearer to the camera than the subject. Since most of the light on the face is coming from above it is wise when possible to provide a reflector to ensure that some of the illumination is reflected into the eyes and under the chin. If the sitter is wearing a white dress this may not be necessary but in all other cases a reflector in the form of a plain white card at least 20×16in should be placed on the sitter's lap or at an angle on a chair in front of the subject. For close-ups the sitter should even hold it higher.

When the ceiling is very high it is better to use one of the walls, provided it is white or light in tone. The flash should be aimed at a point well in front of the sitter and a little above. In a small room there will probably be enough ambient reflection all round to provide the necessary illumination for the shadows. If not, it will be essential to provide a reflecting surface such as a large white card placed on the other side of the sitter and some way in front. Only practical experiment will establish the best position for the required effect.

Exposure should be calculated from the guide number as described in Chapter 7. The distance between flashgun and reflector is added to the distance between reflector and sitter and the total divided into the guide number to obtain an aperture figure. To allow for absorption the aperture should then be opened up by two stops. In practice this usually means that a very powerful gun, a fast film and a very large lens is required. The method is also somewhat hit and miss so a more satisfactory answer lies in the use of an umbrella or parasol reflector.

Using umbrella bounce

This is a very convenient and reliable method of employing flash and it is particularly suitable for cramped home conditions. It simply consists of a folding umbrella made of a white material, usually nylon, about 2ft 6in in diameter which has a fitting at the handle end to enable it to be attached to a tripod. A shoe to take a flashgun is also fitted at this end and either electronic flash units or flashbulbs can be used.

This arrangement has two great advantages. First, the shape of the umbrella ensures that it catches and reflects most of the light if the gun is at the right distance from it. This makes shorter exposures possible and the light is directed more precisely than when flash is merely bounced from a wall or ceiling.

Second, as the distance from the flashgun to the reflector is always constant the achievement of correct exposure is much easier, especially after an initial series of tests have been made (see Chapter 7).

However its great advantage for portraiture is that the position of the

Fig. 17 *Bounced flash is ideal for high key subjects and when kept to one side and a little above, it will give good modelling. Note the reflection under the chin from the white shirt. A separate flash fired by a slave unit was used for the background.*

Fig. 18 *The soft lighting and plastic modelling achieved with bounced flash is particularly suitable for glamour subjects and it facilitates the use of a large aperture, thus putting all but the eyes a little out of focus.*

Fig. 19 *The umbrella used for bouncing the flash can be seen reflected in the spectacle lenses. Only a slight adjustment of position or movement of the head would remove the reflections without losing the modelling. This was taken with the sitter close to a dark green wall on his right and only one flash was used.*

Fig. 20 *Instead of an umbrella the flash was bounced off a nearby white wall. The catchlight in the eye comes from a room light which was stronger than the bounced flash.*

flash can be easily adjusted and the unit can be placed to get the precise type of modelling required. In this respect it can be treated just like the photoflood lighting described in the last chapter. A tilting head to the tripod is necessary so that the reflector can be angled to the sitter just like an ordinary main-light unit, and if a torch is attached to or near the flashgun a good check of the modelling can be made.

In a small room one umbrella unit may be sufficient because a certain amount of light escapes through the nylon and produces sufficient general reflection to illuminate the shadows. The degree of contrast can be varied considerably by varying the distance between the sitter and the wall on the opposite side to the flash. A high degree of contrast can be obtained by placing the sitter near a very dark wall or, alternatively, by using a large room and seating him or her in the centre.

Another advantage of the umbrella unit from a domestic point of view is that the light is very even so it can be placed much nearer the subject than direct lighting without danger of the forehead being much lighter than the chin. The light is also very much softer and the cast shadows are very diffuse. The result of this is that a considerable amount of subject movement can be tolerated without unpleasant shadows appearing; unlike direct light where the slightest movement can cause a nasty nose shadow or an unwanted highlight.

By the same token, umbrella flash is ideal for young babies and pets who are inclined to fidget. Incidentally, the dreaded 'red-eye' effect caused by flash reflected from the retinas of the eyes is impossible with bounced flash when it is off the camera. It is worth mentioning here, also, that flash does no harm to a baby's eyes and it will hardly be aware of bounced flash. This is a point on which medical experts agree.

Yet another advantage of this form of flash is that apart from the lack of a studio atmosphere and a lot of trailing wires, the pupils of the eyes are not reduced to a pinpoint and eyes look more natural as a result. Any tendency to squint is also avoided. In fact the results look very much like those produced in diffused daylight.

Bounced flash can also be used for self-portraits very satisfactorily because of the latitude in light placing and subject angle without creating unpleasant shadows. The set-up can be as for normal portraiture and an extension lead can be used to fire the shutter and flash—a much more convenient arrangement than the use of a delayed-action release.

Harder lighting, approximating to weak sunlight, can be obtained by using an opaque umbrella instead of the semi-opaque white nylon type. This can be lined in silver or gold paint or foil. These are more efficient as reflectors so they permit shorter exposures and they cast more definite shadows. On the other hand, unless they are employed in a very small room, some form of fill-in light will be required. The silver lining is intended for black-and-white work and the gold one for colour portraiture because it gives a flattering warmth to flesh tones.

The fill-in light can be a large white card but more control over the result can be exercised by using a second flash and keeping it near the camera/subject axis in order to avoid cross shadows. In practice it is probably better to attach it to the camera and reduce its strength as required by covering it with layers of handkerchief. The handyman could easily devise a more elegant method by making covers for the flash window out of opal or ground Perspex. Another method that can be adopted in a small room is to turn the flash so that it bounces off the wall behind the camera and this will certainly avoid any danger of the fill-in flash casting shadows of the sitter on the background.

It will be obvious that computer flashguns cannot be used on the automatic setting when they are directed into a reflector. Even those fitted with an extension sensor can only be used when a single umbrella reflector is used

Fig. 21 *Perfect modelling is only obtained when the bounced flash unit is to one side as indicated by the nose shadow here. Contrary to popular belief it should never be directly in front, even for high key pictures.*

otherwise both guns would affect the reading. The ideal arrangement when two guns are used is to set them to manual and allow the camera to fire the fill-in flash while the main flash is fired by a slave unit which is pointed towards the flash on the camera. Most slave units are sensitive enough to respond even when the fill-in flash is considerably diffused.

It is wise to have the camera on a tripod so that the relative distances and strengths of the main light and fill-in light can be duplicated whenever required. Once more, a series of tests with the fill-in light at different strengths is recommended and all data should be carefully recorded for future use.

Lighting the background

With photoflood lighting or direct flash it is usually necessary to light the background separately but this is not so essential with bounced flash. Because of its softness the shadows cast on the background are much more acceptable and on anything but white, are scarcely visible. When the flash unit or units are at a reasonable distance the background can be almost as well illuminated as the sitter because the sudden falling off of light power which occurs when near-point sources are used no longer applies.

However, there are occasions when more precise control over the background tone may be required and this means using a third flash unit. This can create several problems. First, there is a danger of over-lighting because the bounced flash on the subject is so much weaker than a direct flash on the background. Second, it will have to be activated by an extension cable if it is placed behind the sitter or, if it is at the side where a slave unit can be used, it may well cause flare in the lens unless a large shield is employed.

The best place for it would be behind the sitter and directed, not at the background, but on to a white card angled so that it throws the light upwards on to the required area of background. In most cases it can be placed very low down or even on the floor provided that there is enough distance between the back of the sitter and the background.

Mobile bounced flash

The even spread and diffused nature of bounced flash means that a lot of subject movement can be tolerated without risk of unpleasant shadows and this makes it ideal for photographing pets or babies. Posing these subjects and getting them to stay in one spot is often very difficult so a means of following their movements with bounced flash on the camera has obvious advantages.

All that is required is a reflector, probably only a few inches square made out of white card and fixed to the flashgun at an angle. The gun itself is reversed so that it faces rearwards and upwards and the reflector directs the light towards the subject. At least one gun manufacturer provides this facility

Fig. 22 *Quite strong shadows can be obtained with bounced flash if it is close to the subject and the room is large or the walls are dark, thus minimizing ambient reflections.*

but any handyman could easily devise a suitable reflector. One firm has produced a most ingenious umbrella which is blown up like a balloon and fixed over the gun so that it is, in effect, very similar to the rigid umbrella units but it only weighs an ounce or so. This means that it can be used on the camera and carried around with it instead of being anchored to a tripod.

Either of these units will enable the operator to crawl around on the floor and follow the movement of the baby or the animal, firing away when ever a good expression is seen. Having the flash on the camera avoids the nuisance of trailing wires if a battery-fired gun is used, but since it is on the camera the lighting will be flatter than when the source is at an angle to the subject. For this reason it is much more satisfactory for colour than for black-and-white portraits. If the latter is employed the negative should be given at least 25% extra development in order to build up contrast.

A little more apparent contrast will be obtained if both the floor and the background are dark because there is less ambient reflection but this lighting must really be regarded as a compromise to cope with a difficult subject. For most purposes, as already discussed, the light source should always be at an angle to the subject/camera axis. The only other exception is when using flash as a fill-in outdoors and this is described in Chapter 13.

When working on the floor and using colour, it is necessary to guard against colour casts. A green carpet may well reflect a lot of green on to the subject's face and if a neutral grey or white carpet is not available it would be better to put down a sheet or blanket which is neutral or has only a pastel colour. If flashbulbs are used instead of electronic flash some provision should be made for disposing of them as they are used. A hot bulb can easily damage the carpet or burn an inquisitive child's hand.

7: Exposure Calculation

Average readings—adjustment for subject—reflected light reading—incident light meters—spotmeters—using grey cards—exposure for flash—guide numbers—bounced flash exposure—flash outdoors — synchro-sunlight — inverse square law

MANY otherwise good portraits are spoiled by incorrect exposure and it is a more frequent error today than it used to be because people rely too much on exposure meters, especially those that are built into cameras of the single-lens reflex type. All such meters take an average reading of the whole subject, including the background, and this may be correct when there is an even distribution of tone all over the picture but far from correct when there is a predominance of light tones over dark or vice versa.

A little thought will show that if there is a brightly-lit figure against a large area of black background an average reading by exposure meter will cause the face to be over-exposed and, conversely, a dark figure against a very bright background may be under-exposed. Even with identical backgrounds there could be a big difference in the meter readings if the subject is wearing light clothing for one shot and dark for another.

In all portraiture it is the face that matters and exposure must be based on getting the right exposure to reproduce tone and to bring out the modelling in the flesh. Exposure meters can be a useful guide if they are not slavishly followed and if allowances are made for the variations mentioned. Unfortunately there is a lot of talk about latitude in modern films implying that one can get a good picture with a wide range of exposures—even as much as three or four stops either way—but this can be very deceptive. It is true that one might get a negative and some sort of print with the aid of extra hard or extra soft papers but only correctly adjudged exposure will give the tonal

71

gradation and detail in both highlight and shadow that is essential for a portrait.

This applies to both black and white and colour. Colour transparencies allow very little latitude because only a slight over-exposure will produce washed out colours and loss of detail, while an equal amount of under-exposure will produce a transparency so dense that it is a strain to view it. If they are to be projected as slides transparencies should all be of an even density.

The most common error is over-exposure both in outdoor and indoor portraiture, no doubt due to a subconscious feeling that it is better to be safe and 'make sure of something' on the negative. Many people do not trust the ASA figures given by the manufacturers and so they set the speed slightly lower on their meters. They will set a 400 ASA film at 320 ASA, especially as so many developers in use today have the effect of increasing film speed. Even with colour transparencies it is better to have a slight degree of under-exposure than of over-exposure because it will at least ensure good colour saturation so the ASA speed should, if anything, be set higher than lower.

There is no doubt that the ideal way of measuring exposure is to take a meter reading from the highlights and from the shadows of the face alone, thus eliminating all reading from the background, the clothing or any other area. This is almost impossible with the built-in meter because it would mean taking the camera right up to the sitter's face, a course not calculated to put him or her at ease. A separate meter makes it possible to take close-up readings but even this can be rather disturbing. It can be overcome by the use of a spotmeter which has such a narrow angle of view, usually about 1°, that readings of both shadow and highlight areas can be taken from the camera position.

Unfortunately spotmeters are very expensive and most amateurs will need to make the best of what they have got. This is not as bad as it sounds because with a little experience most people are able to adapt a general reading to the particular circumstances. The main advantage of a meter that can be used close enough to give accurate readings of both highlights and shadows is that the degree of contrast can be assessed and thus one can ensure that it comes within the range of contrast that the film can accommodate. Some meters show the exposure that must be given to cover a specific ratio of highlight to shadow.

It was explained in Chapter 5 that if the contrast in the subject itself is greater than the film can accommodate, or that the printing paper in turn can take from the negative, something must be sacrificed. If the exposure is based on retaining tone and detail in the highlights the shadows will be under-exposed and devoid of detail and, conversely, exposure sufficient to record shadow detail will cause the highlights to be burnt over. A compromise exposure will mean lack of detail at both ends of the scale and produce what is popularly known as a 'soot and whitewash' effect.

On many types of subject one would also have to take into account the

Fig. 23 *An average meter reading on a subject like this would probably not indicate enough exposure for the subject, especially the dark clothing, because it will be influenced by the light background.*

Fig. 24 *An average meter reading over the subject would be so influenced by the very large area of dark clothing and background that it would result in over-exposure and loss of tone in the face.*

actual tones or colours. Light tones in the highlights are going to require less exposure than dark tones that are well lit and, conversely, light tones in the shadow areas are going to reflect more light than dark tones so the actual range of subject contrast could be greater than the range of lighting contrast.

Fortunately this is no great problem in portraiture because the variation of tone over the flesh of the face is almost negligible and, when evenly lit, tone variation in the photograph is achieved almost entirely by variations in the strength of the light on different parts of the face. This means that one can take a reading from anything which might be said to represent an average flesh tone and it is generally reckoned that a light grey tone which is about 18% to 20% of black will give a fairly reliable reading. Kodak in fact market a grey card about 10×8in, which is 18% grey. If this card is held in front of the sitter's face, or where the subject will eventually sit, a close-up reading can be taken from it. The meter must be close enough to avoid taking in anything but the grey of the card and it is important to ensure that the hand or the meter does not block any of the light. This is easily observed if a shadow can be seen on the card.

Whether indoors or outdoors the card reading is likely to be a good indication for most subjects but it is still a good idea to bracket exposures by giving one at half stop less and one at half stop more than indicated by the meter, especially when using colour transparency material. The card is based on the normal skin tone of a European who is not exceptionally sun-tanned. For red or yellow skin another half stop may be necessary and for brown or black skin at least one stop larger will be required.

Incident light reading

When using a meter on the subject or on a grey card, it is measuring light reflected from the subject but another method is to read the light falling on the subject and this is known as the incident light method. The meter is held near the sitter but facing away from him so that it receives the same light that is falling on the subject.

The principle on which the light reading is based is that of measuring the brightest spot of the subject by substituting it with a piece of white, opal translucent material, called a receptor, placed in front of the meter window. It usually takes the form of a hemisphere rather like one-half of a ping-pong ball, although in some cases it is conically domed. It takes in an angle of about 180° and this underlines one of the chief advantages of incident light reading—it does not rely on a limited acceptance angle and so eliminates the necessity of going right up to the subject.

Although incident light meters are designed to be pointed directly at the light source it is usually quite satisfactory to point them towards the camera because of the wide angle of acceptance. A hemispherical receptor used in this position is illuminated in a similar manner to the face.

The use of the incident light method ensures highlights of a constant density and this is particularly advantageous in colour transparency material

where faulty exposure can cause faulty tones and upset colour balance. Most of the better makes of ordinary exposure meter can be converted in a moment to incident light reading by the use of a clip-on semi-hemisphere or cone and when purchasing a separate exposure meter the small extra cost is a wise investment.

Owners of fully automatic cameras which have no provision for a manual over-ride will have to make allowance for a subject requiring more exposure than normal by setting a lower film speed on the camera and for subjects requiring less exposure, a higher film speed must be set. The only real advantage of built-in meters is for average subjects such as landscapes and even here, they can be deceptive unless used with an understanding of the variations which may be necessary under different lighting conditions. Most experts agree that there were far fewer failures through faulty exposure before built-in meters were invented, at least among keen photographers if not snapshotters.

Exposure for flash

The ordinary selenium cell or cadmium-sulphide exposure meter is, of course, useless for flash but there are meters especially made for measuring the strength of the flash falling on the subject. They are pointed towards the light source and the flash is fired and registered on a cell with a memory circuit. However, they are expensive and for most amateur purposes the normal method of calculation by means of a guide number is adequate and reliable.

Every flashbulb and every electronic flashgun has a guide number for every speed of film. Many flashguns have a rotating calculator on the case and setting a pointer to the ASA speed rating of the film in use gives the aperture to be used at different distances. It is the aperture figure multiplied by the distance which gives the guide number. In other words if the guide number is 110 it will require an aperture of f/11 at 10ft, of f/22 at 5ft and approximately f/8 at 14ft.

The guide number is based on the flash being used directly on the subject and in a normal reflector. Flashcubes and electronic guns have reflectors built-in and this has been allowed for in the manufacturer's figures. The latter are also based on use in average conditions where there is a certain amount of ambient reflection from walls and ceilings. In darkness outdoors or in a very large and dark room more exposure may be required.

In any case the manufacturer's guide numbers are often very optimistic and unfortunately there is no accepted standard method of measurement so tests should always be made before embarking on any important or unrepeatable work. This is easily done by photographing an average subject at a fixed distance and varying the exposures by half a stop. The best negative will indicate the correct guide number if the aperture used for this is multiplied by the distance. From this it will be a simple matter to calculate the guide number for other speeds of film.

It should be noted that the guide number for some continental flash materials and films is based on metres so the answer will be in metres instead of feet.

All guide numbers are based on the flash duration being less than the time that the shutter is open so that the whole of the flash is used for the exposure. On most single-lens reflex cameras allowance has to be made for the time that the slit in the focal-plane shutter takes to travel across the film. Usually this means that the fastest shutter speed practicable for electronic flash is 1/60th second or, in a few cases, 1/125th second, while for flashbulbs the fastest permissible speed may be only 1/30th second. There are special bulbs called FP which have an extended burning time but they are more expensive and not ideal for amateur use at home.

This limitation does not apply to cameras with between-lens shutters which will synchronize at any speed. However, if the shutter speed is shorter than the burning time the aperture must be opened up to compensate and the guide number will be less. A table of the revised guide numbers or altered apertures is usually given in the instruction book or leaflet.

Indoors, the rather slow shutter speeds required for focal plane SLR cameras are not a drawback unless there is enough ambient light in the room to record an image without the flash, in which case a double image may result. Outdoors, when flash is used as a fill-in for the shadows, slow speeds can be a distinct drawback as will be seen later but although inconvenient the problem can be overcome.

When flash is used direct, it should be off the camera or the lighting will be extremely flat and there will be an ugly rim of shadow from the background all round the head. Because the light falls off so rapidly and largely conforms to the inverse square law, it is in most cases necessary to provide a fill-in flash or a strong reflector as described in Chapter 5. There is nearly always a tendency to over-expose with flash and thus burn out the tone gradation in the face so the fill-in flash can make the situation even worse by adding light to the highlights as well as the shadows if exposure is not reduced.

There is no way of calculating the effect with accuracy and only practice and experiment will produce a satisfactory answer but a good starting-point would be to close down by half a stop even though the fill-in may be diffused or bounced.

The biggest problem arises with bounced flash used for the main light. A rough guide can be obtained by adding the total of the distance from flash-to-reflector and reflector-to-subject, and then dividing the total into the guide number to obtain an aperture figure. This should then be increased by one or two stops according to the nature of the reflecting surfaces but, as stated in the last chapter, only tests can establish the perfect answer. A fixed reflector such as an umbrella or an angled card on the flashgun provides at least one standard and reduces the possibility of error.

Sometimes the use of bounced flash will mean that the required aperture is larger than the camera lens can provide, especially when slow colour film is employed. For this reason it is always advisable to purchase the most powerful gun possible if it is to be used for portraiture by bounced flash alone.

Fig. 25A *Fill-in flash should be so balanced that it is not obvious that it was used. Only the catchlights in the eyes give it away.*

B *This shows far too much flash. It has overpowered the daylight because it was used direct.*

C *Another example of overdone flash although in this case some of the modelling has been retained.*

D *Here the fill-in flash was bounced from a reflector and the effect is much more natural.*

However, this may be too cumbersome for other purposes and one answer is to use two guns together or two flashbulbs together. In the case of electronic flash the second gun can be fired by means of a slave or a two-way connector on the camera. For the latter it is essential that both guns are of the same polarity and preferably of the same make and power. Two flashbulbs can be fired by means of a special holder and, in fact, there are bulb guns on the market which can fire up to six bulbs at once. This is naturally a rather expensive form of flashlighting and the inconvenience and delays caused by replacing a number of hot bulbs between each exposure is not conducive to a smooth sitting.

In theory the use of two guns of equal power ought to mean a halving of the exposure or, in other words, a demand for one stop smaller than that given by the guide number. In practice some of the light seems to get lost through scatter or absorption and this usually amounts to about one-third of the extra light. The exception to this is umbrella flash and if the guns are angled so that they both fire into the centre a reduction of one stop can safely be given.

In a small room an aperture of f/4 with colour film of 64 ASA rating and a medium-size unit electronic flashgun ought to be feasible when an umbrella unit is employed at about 5–6ft from the sitter. This would also be about right for a flashcube. However, exposures will vary considerably according to circumstances such as the power of the gun and the nearness of reflective surfaces so it is essential to make a series of tests, noting carefully the distance of the light source from the subject.

Electronic flash is generally considered correct for daylight type colour film and flashbulbs which are dyed blue also give the right colour temperature. However, some people prefer more warmth in portraits so an ultra-violet (UV) filter is often employed over the lens and this makes no difference to the exposure required. For men, where some character is required, the cooler effect is probably better and in black-and-white work a very pale blue filter can give more tone to the flesh and, in particular, lighten blue eyes with advantage. This filter will almost certainly require an increase in exposure of at least half a stop.

Those who like to experiment with multi-coloured lighting can use coloured gels or filters over the flashgun. This of course will cut down the power of the light quite considerably and the simplest way to work this out is to point an exposure meter at a bright subject and take readings with and without the gel over the meter window. It will be easy to work out the proportion of light lost and then to adjust the aperture accordingly.

Exposure for flash outdoors

Flash can be and is used outdoors in two quite different ways. First it can be used on a very dull day to simulate sunlight and add contrast. It should then be angled to give good modelling as already described for indoor portraits

but as far as possible it should direct its light at the same angle and from the same direction as the sun. It has already been said that even on a very overcast day the light is still directional, although very diffused, so a different angle for the flash could look very unnatural. In effect, the flash is merely augmenting the sun and so exposure for the highlights must be calculated on the basis of sunlight plus flash. A method that works well in practice is to take a meter reading in the ordinary way and then divide the chosen aperture into the guide number to obtain a figure for the distance at which the gun would normally be placed when lighting by flash alone. This would give a considerable degree of over-exposure so the distance is doubled and this effectively reduces the flash illumination by a quarter. It might be thought that it would be easier to reduce the strength of the flash with layers of handkerchief as described earlier in Chapter 3 but this is one occasion when we want to maintain sharp shadows in order to simulate sunlight and layers of handkerchief would diffuse them too much.

To give an example: if the meter reading on the subject gives 1/125th second at f/8 and the guide number for the flashgun is 80 the normal position for the gun would be $\frac{80}{8} = 10$ft but as the flash should not take over as the principal source of illumination it should be placed at a distance of 20ft from the subject. If a camera is used which will not synchronize at a faster speed than 1/60th second the formula becomes 1/60th at $f/16 = \frac{80}{16} = 5$ft so the flash is placed at 10ft. This method is far from scientific but it works in practice and it is more satisfactory than working from the guide number without any adjustment. This can cause over-exposure or, if allowance is made for the two light sources and the exposure reduced accordingly, the subject will look unnatural because the background will be under-exposed and too dark. Flash at the distances described will merely be extending the contrast range.

Flash on the camera is often used by press photographers to ensure a picture under difficult conditions and for that purpose it is justified, but it should never be used on the camera for serious portraiture outdoors because two sources of light are then seen in the result. This is unnatural and the modelling is often lost.

Fill-in flash

The second and more frequent use of flash outdoors is as a fill-in and it is often wrongly described as synchro-sunlight. It is not taking the place of the sun, nor augmenting it, but performing the same function as the fill-in light described in Chapter 6. It is solely to reduce contrast to proportions that the film and printing paper or transparency can accommodate.

As such it is a very useful technique when the sun is so strong that the shadows would be absolutely black if exposure were based on the highlights. It is especially valuable for colour portraiture outdoors because colour films have a smaller contrast range than black-and-white films. Fortunately, as already mentioned, flash is roughly the same in colour temperature as noon

Colour Plates

(facing this page)

1 Reproduced from a colour print on Kodak R14 paper which was made from a Koda-color negative. Portraits like this with simple diffused lighting can easily be made at home.

2 Reproduced from a Cibachrome print made by direct reversal from a Kodachrome transparency. Taken with bounced flash from a white umbrella, it shows the value of soft lighting for colour.

3 A garden which is private is ideal for figure portraiture. The warm but out of focus colours in the foreground help to give an impression of depth and they form a good contrast to the background without clashing. Reproduced from a Cibachrome print made by direct reversal from an Agfa CT21 transparency. **Olympus OM-1: 50mm lens: 1/25sec at f/4: hazy sunlight.**

4 **Top:** *A garden portrait in which the fill-in flash has been far too strong and killed the natural sunlight.*
Lower: *A better balance. The flash is still a trifle too strong but the effect is acceptable.* **Pentax SV: 90mm lens: Kodachrome 11.**

5 Side lighting is essential to bring out the texture of animal fur, especially with colour, and even on dull days the direction of the light is important. **From an Ektachrome transparency.**

6 The sky makes a clean and uncluttered background in the right colour for the average portrait. The low viewpoint is also flattering for this type of subject and this picture shows that it is sometimes an advantage to use a rectangular instead of upright format. **Nikon F: 135mm lens: 1/125sec at f/8: Agfa CT18.**

7 **Top:** *Cast shadows from trees can sometimes be attractive and they are a good compromise in bright sun when no fill-in flash is available. This picture also has a touch of originality because the subjects are not looking at each other. Notice how the baby is sharp, the father less so, and the background very much out of focus.* **Praktica L2: 50mm lens: 1/250sec at f/4: Agfa CT18.**
Bottom: *Portraits taken directly against the light have a nice luminosity, especially when projected as transparencies. The sun was very low here so contrast was not too high and a tiny flashgun on the camera was sufficient for fill-in.* **Reproduced from a Kodachrome 25 transparency.**

8 Portraits of theatre and TV personalities justify the use of theatrical lighting and spotlight effects that would be out of place for the average subject. This picture of Derek Nimmo is reproduced from an Agfa CK (artificial light) transparency. **Mamiyaflex: 120mm lens: 1/60sec at f/8.**

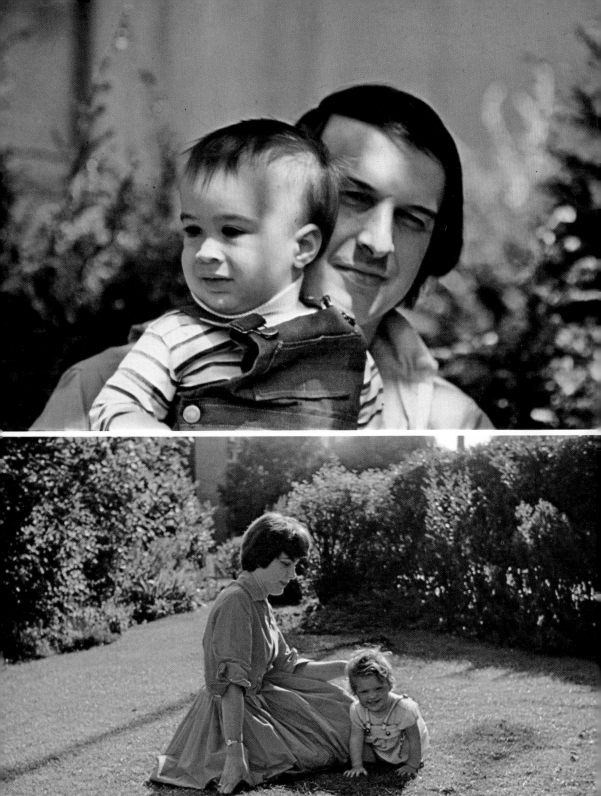

daylight but it can produce a slightly colder effect than late afternoon sunlight and a UV filter may be used to avoid any tendency to blueness in the shadow areas which the flash is being employed to fill.

It goes without saying that the fill-in flash must not be allowed to create its own shadows so it must be placed on or very near the camera/subject axis and preferably diffused. It is obviously more convenient to have it on the camera and the exposure calculated accordingly. It is also very important to ensure that the illumination from the flash does not 'kill' or take over from the sun. The result will look most unnatural and if the fill-in becomes the major source of illumination the lighting will be flat and most of the modelling will be lost.

There are several methods of estimating exposure and some that have been published would require a mathematician or an electronic calculator to produce a result before the subject gets bored to distraction or disappears from the scene. A way which has proved to be quite reliable in practice is to take a meter reading of the highlights to obtain a correct shutter speed/ aperture combination. The aperture figure is then divided into the guide number to obtain a distance for the flash to be placed in front of the subject. In the normal way this might lead to over-exposure because the flash is added to the sunlight but since the flash is being used in the open without the benefit of reflecting walls and ceilings its actual value is reduced by at least one stop.

To quote an example: if the meter reading for the highlights is 1/60th second at f/11 and the flash guide number is 88 the distance for the flash will be $\frac{88}{11} = 8$ft. However, if the camera is at any other distance it will mean putting the flash on a tripod and this may be very inconvenient, especially if it comes behind the camera and a long extension lead is required. The remedy is to put the flash on the camera and reduce its power with a layer or two of handkerchief, bearing in mind that each layer will reduce it by about one-half. In the case quoted, if the camera is about 6ft 6in from the subject, one layer of handkerchief will give approximately the same effect as a naked flash at 8ft.

This arrangement will provide a fairly strong fill-in for the shadows; approximately a 2:1 ratio which is very suitable for colour work. If more contrast is required the strength of the flash must be reduced further and a second layer of handkerchief will probably be about right for a full gradation black-and-white print.

Automatic electronic flashguns employing a sensor to read the reflected light should not be used in this mode for fill-in flash. Fortunately all automatic guns can be switched over to normal manual use. Likewise, automatic cameras can usually be switched to manual use. On the few that do not have this facility some experiment may be necessary but in most of them the user sets the aperture and the camera sets the shutter speed to match so that the technique described can be applied. Automatic cameras on which the user sets the shutter speed and the camera alters the aperture are not very

satisfactory for synchronized fill-in flash because the distance of the flash is controlled by dividing the aperture into the guide number. In any case, as already explained, automatic cameras take an average reading of the whole scene and this usually means under-exposure in outdoor portraiture because the sky's brightness influences the reading. If the film speed setting is reduced to compensate for this, the flash calculation is affected.

With all fill-in flash it is important to ensure that there is nothing in the foreground or well in front of the subject that will catch the flash because it will be very over-exposed unless it is extremely dark in tone. The inverse square law states that light falls off inversely as the square of the distance

Flashgun	Shutter Speed 'X' Synchronization—Electronic Flash				
BCPS output	1/30sec	1/60sec	1/125sec	1/250sec	1/500sec
500	2ft	$2\frac{1}{2}$ft	$3\frac{1}{2}$ft	4ft	$5\frac{1}{2}$ft
—	3ft	$3\frac{1}{2}$ft	5ft	$5\frac{1}{2}$ft	8ft
	4ft	$5\frac{1}{2}$ft	8ft	9ft	13ft
700	2ft	$2\frac{1}{2}$ft	4ft	$4\frac{1}{2}$ft	$6\frac{1}{2}$ft
	3ft	$3\frac{1}{2}$ft	$5\frac{1}{2}$ft	6ft	9ft
	$4\frac{1}{2}$ft	6ft	9ft	10ft	15ft
1000	$2\frac{1}{2}$ft	$3\frac{1}{2}$ft	5ft	6ft	8ft
	$3\frac{1}{2}$ft	5ft	7ft	8ft	11ft
	$5\frac{1}{2}$ft	8ft	11ft	13ft	18ft
1400	3ft	4ft	6ft	7ft	9ft
	4ft	$5\frac{1}{2}$ft	8ft	10ft	13ft
	7ft	9ft	13ft	15ft	20ft
2000	$3\frac{1}{2}$ft	5ft	7ft	8ft	11ft
	5ft	7ft	10ft	11ft	15ft
	8ft	11ft	15ft	18ft	25ft
2800	4ft	6ft	8ft	10ft	13ft
	$5\frac{1}{2}$ft	8ft	11ft	14ft	18ft
	10ft	13ft	18ft	20ft	30ft
4000	5ft	7ft	10ft	12ft	15ft
	7ft	10ft	14ft	17ft	21ft
	11ft	15ft	20ft	25ft	35ft
5600	6ft	8ft	12ft	15ft	18ft
	8ft	11ft	17ft	21ft	25ft
	13ft	18ft	25ft	30ft	40ft
8000	7ft	10ft	15ft	17ft	20ft
	10ft	14ft	21ft	24ft	28ft
	15ft	20ft	30ft	40ft	50ft

which means that for every doubling of the distance between the light source and the subject the intensity of the illumination is reduced by a quarter, while at three times the distance it is reduced to one-ninth and so on. Although this strictly applies only to a point source of light a flashbulb or flashgun is near enough to a point source to cause a drastic fall-off in strength. This means that when exposure is calculated correctly for a subject at 6ft an object at 4ft can be very over-exposed and an object at 8ft very under-exposed. The effect is not quite so drastic when the source is diffused or larger in area but it should nevertheless be taken into account.

Another approach to the estimation of correct exposure for fill-in flash is to use a table which is based on the ratio of flash to sunlight and not on film speed. The following table is a simplified version of one published by Eastman Kodak and in practice it has proved very reliable.

It is only necessary to decide on the exposure for the sunlight and set the aperture and shutter speed accordingly. The distance from the subject at which the flash should be placed is then read from the table. The upper figure is the distance in feet for an approximate ratio of 2:1 which is good for colour portraits; the middle figure gives a ratio of about 3:1 which will produce normal full-grade negatives in black and white while the lowest figure will give a ratio of about 6:1 or, in other words a very slight fill-in just to give a suggestion of detail in the shadows.

Where the distances are impracticable there is a choice between using a smaller aperture with a correspondingly longer shutter speed or masking the gun with a handkerchief on the basis that each layer will approximately halve the power. The table demonstrates the advantage of using the smaller guns for fill-in flash unless the subject is at a greater distance than normal for portraiture.

| | FLASHCUBES | | | | | | |
| | 'X' Synchronization | | 'M' Synchronization | | | | |
Shutter Speed	1/30sec	1/60sec	1/30sec	1/60sec	1/125sec	1/250sec	1/500sec
Flashcube	$3\frac{1}{2}$ft	$2\frac{1}{2}$ft	$2\frac{1}{2}$ft	$3\frac{1}{2}$ft	4ft	$3\frac{1}{2}$ft	4ft
or	5ft	$3\frac{1}{2}$ft	$3\frac{1}{2}$ft	5ft	$5\frac{1}{2}$ft	5ft	$5\frac{1}{2}$ft
Magicube	8ft	6ft	6ft	8ft	9ft	8ft	9ft

8: Cosmetic Lighting

The best side of the face—lighting the eye sockets—coping with big noses, bald heads and double chins—subduing and emphasizing character lines—blotchy skin and freckles—soft focus—fog attachments—star attachments—grain for effect

A GOOD portrait photographer uses light creatively. He or she is not content to use it purely as a means of recording what is in front of the camera but they use it to create an effect, a mood or an atmosphere that is appropriate to the sitter and brings out his or her true character or, at least, the photographer's interpretation of that character. The good photographer also uses light to correct deficiencies and flatter the subject; or sometimes even to exaggerate them and enter the field of caricature.

Nearly every female sitter will tell you that one side is her better side but this does not necessarily mean that it is the side to emphasize in the photograph. Very few people have symmetrical faces and one side is nearly always fatter or wider than the other. If the main light is directed on to the wider side and the other is kept in shadow the viewer's imagination leads him to think that the shadow side is equal so the total impression is that the face is wider or rounder than it really is. Conversely, if the narrower side is emphasized by lighting it, the viewer is led to think that the face is narrower than it really is.

This can be useful when it is desired to make a round or moon-like face look narrower or a very thin face look more round, so it is worth studying the face before lighting it. The effect can be varied considerably by the degree of contrast. Very dark shadow with only a suggestion of detail is obviously going to have the maximum effect because it will leave so much to the imagination.

The position of the main light can also be varied to correct defects or emphasize good features. For example if the sitter has very deep eye sockets a lowering of the light so that it illuminates them rather more than normal will make them appear shallower. Conversely if the sitter has shallow eye sockets and rather bulging eyes the light on them should be reduced by raising the lamp considerably and possibly taking it farther round so that the eyes

84

Fig. 26 *A full-face photograph which shows roughly the correct proportions of the head is at top left. Next to it is a print made up of two right-hand halves joined together and on the right a similar print made up of two left-hand halves. They show conclusively that one-half of the face is wider than the other although it looks symmetrical in the first photo. By emphasizing one-half or the other with light a face can be made to look narrower or wider than it really is.*

are illuminated mainly by the fill-in light which is softer and tends to flatten the planes by virtue of its position.

The nose is often a real problem especially when it is large and bulbous or hooked. If the main light is placed too much to one side it will cast a shadow of the nose on to the cheek and make it look even worse than it is. In a very bad case the only remedy is to keep the lamp high up and well to the front. This will cast a shadow on the upper lip that will not give away the size or shape. An alternative that can be adopted if side lighting is essential for other reasons is to keep the side on which the nose shadow falls in near or complete darkness so that the cast shadow is absorbed. This of course will only be appropriate for subjects like male character portraits where dramatic or low-key lighting is chosen.

The top of the head can be emphasized a little by raising the light and at the same time raising the camera viewpoint in relation to the face—a point that is dealt with in the next chapter. This can be an advantage when the hair is particularly attractive but obviously a disadvantage for a bald head. A high angle will also tend to lose or cancel double chins but if the face is square to the camera it will tend to look rounder. When placed at a high angle the light will also tend to conceal a weak chin if the face is more or less square to the camera. A lower camera viewpoint also helps a weak chin when used in conjunction with a high angle main light. It is an advantage if the chin is kept more in shadow than the rest of the face and this is easily done if the lamp is one which tends to be brighter in the middle than at the edges. Tilting it so that the edge of the beam covers the chin and the neck is easy to arrange and this often has the advantage of keeping light off the clothing which, if it is light in tone, or heavily patterned, could draw too much attention to itself. Alternatively one of the barn doors described in Chapter 3 could be adjusted so that it partly shields the chin.

Barn doors can also be useful for shading ears which tend to become dominant if they are well lit, especially when surrounded by dark hair and beards. No part of the subject should ever appear in a lighter tone than the highlights on the face and ears in particular should be well subdued in tone.

The question of texture is bound up with the lighting. The more the main light is removed from the camera/subject axis the stronger the texture rendering. This means that if it is desired to emphasize the pores in the skin, as well as every character line and wrinkle, the light should be well to one side. This is often useful in character portraits of old men or men at work and even acceptable in low-key portraits of old ladies of character such as gipsies or flower sellers but not very appropriate for young people, glamour subjects, babies or formal portraits of children.

For these subjects it is better to bring the light nearer the front and not too high above the level of the head. This will reduce the size of the shadows in the crevices, but to get the maximum advantage the lighting should also be in a fairly high key which means that the fill-in lamp should be taken closer in order to reduce the depth of tone in the shadows.

Fig. 27A *These pictures show the distorted perspective obtained by wrong camera viewpoints. On the left the camera was too low and too close so the face is too round and the neck too thick. On the right, the camera was so close that the nose has been greatly exaggerated.*

B *In these two pictures the main light was in the same position but the contrast was reduced too much in the left-hand example so the face looks too round. The right-hand picture is a better likeness.*

Texture is also emphasized when the main light is a spotlight or a deep reflector that projects a narrow beam because the shadows they cast have hard edges. Conversely, texture rendering is reduced when the main light is diffused in a shallow reflector or bounced into an umbrella. It is therefore a good rule to use a spotlight or deep reflector for low-key character subjects and to diffuse the light for high-key portraits especially of children or glamour portraits.

Blotchy skin is sometimes a problem but it can often be reduced by nearly frontal lighting and the use of a pale pink or straw coloured filter in conjunction with a fast panchromatic film. This will often reduce freckles and birthmarks but unfortunately it will also reduce the tone of the lips and make blue eyes darker. This of course applies only to black-and-white photography —there is little that can be done to eliminate blotches or freckles in colour portraiture.

Many black-and-white portraits that were taken in the early part of this century show a marvellous rendering of texture and skin tones. This is because they only had orthochromatic emulsions in those days and these were far less sensitive to red, if at all, than modern panchromatic emulsions. Some professional photographers of men still use orthochromatic films but a somewhat similar effect can be obtained by using a pale-blue filter in conjunction with a medium-speed panchromatic film like Plus X or FP4. This is only recommended for male character portraits but it is particularly valuable in strengthening the tone of the lips and in lightening blue eyes which tend to come out too dark with panchromatic films, especially the fast varieties.

When using panchromatic films on glamour subjects the sitter should be asked to use a rather darker lipstick than normal. The sitter should also be asked not to use too much blue eye shadow on the eyelids because this tends to come out a little darker than normal.

Soft focus effects

Many subjects take on an additional glamour if they are rendered in soft focus. This particularly applies to beautiful women rendered in high-key lighting but it can also be effective with a low-key subject such as a white-haired old lady shown in contrasty lighting against a very dark background.

Soft focus does not mean out of focus. A true and natural soft focus is achieved by having a sharp image overlaid by a diffused image caused by some of the highlight spreading into the darker areas. At one time this effect was achieved by the use of lenses with spherical aberrations and some of them were adjustable by stopping down from a very soft focus to a very slight loss of definition.

Nowadays a similar effect is achieved by lens attachments, placed over the front of the lens like a filter. The most common of these is a supplementary disc of glass that has a clear glass circle in the centre of about half of the total diameter of the disc. The remainder of the disc is of mottled glass or

Fig. 28 top left *Lighting a full face with the source only a little to one side tends to broaden the face and should only be used for narrow faces.*
Top right *If the light cannot be moved for other reasons the head can be turned at an angle to get a narrow effect.*
Left *A high viewpoint coupled with a 45° angle main light that emphasizes attractive blond hair is a good combination for glamour. It has been enhanced by soft focus in this example.*

Fig. 29 *A camera viewpoint a little higher than the head is flattering to the eyes but the main light position should always be chosen in relation to the subject and not to the camera.*

is engraved with concentric rings. Thus the centre of the disc provides a sharp image by allowing rays to reach the lens unhindered and the outer area provides a diffused image. The degree of softness is controlled by the aperture in use. A large lens aperture will obviously take in relatively more of the diffused rays than the unhindered rays while a small aperture will be receiving mostly the light passed through the clear glass centre.

10 An easily made soft focus device. A UV filter is smeared with petroleum jelly but a clear space is left in the centre. The degree of soft focus is controlled by the aperture employed—the larger the aperture the more pronounced the soft focus effect because a higher proportion of image forming rays will be refracted by the jelly area.

A similar effect can be achieved much more cheaply by smearing a UV filter with petroleum jelly but leaving a clear circle in the centre. Another method is to fix a narrow strip of black tape such as lantern slide binding strip across the front of a lens hood. The degree of softness will depend on the distance between this and the lens as well as the width of the tape.

These gadgets give a pleasant effect and a nice feeling of luminosity because the highlights are diffused into the shadows. It is especially noticeable when the background is very dark and the result looks like a kind of luminous halo. It is quite different from the effect obtained by using a diffuser over the enlarging lens. In the latter case the shadows diffuse into the highlights and the image is thereby degraded or at least loses some of its luminosity.

Some portrait photographers place a disc of stretched black chiffon over the lens. This undoubtedly softens the image but it does not have quite the same effect as the discs described because there is no sharp image at all and it merely serves to reduce the biting definition produced by many modern lenses.

There is no doubt that all these devices help to reduce blemishes and give a more glamorous atmosphere to a glamour subject. However, they should not be used on other subjects such as character portraits where crisp definition

91

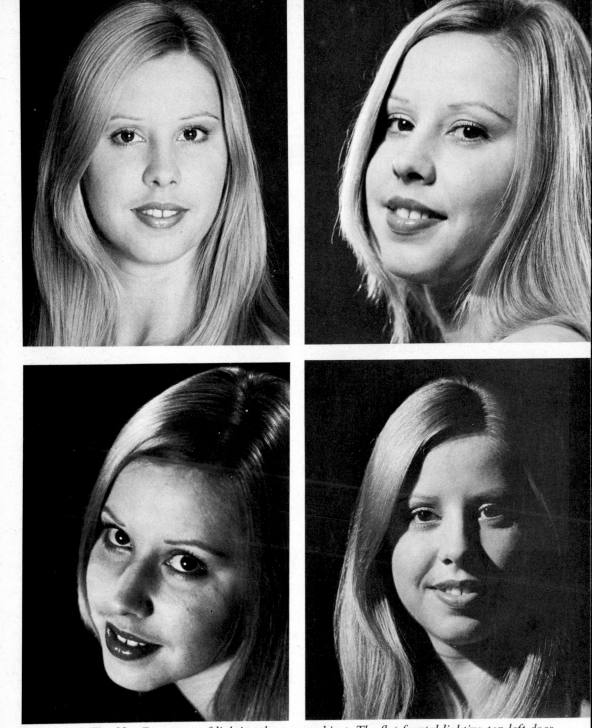

Fig. 30 *Four ways of lighting the same subject. The flat frontal lighting top left does not give a good likeness. The picture top right shows similar lighting but on a three-quarter profile. Because the face is tilted upwards the lamp should have been raised.* **Lower left:** *the head has been tilted towards the camera and the light taken below the level of the face to give a somewhat theatrical effect.* **Lower right:** *dramatic lighting with the main light very high and well to the left makes for impact and accurate modelling.*

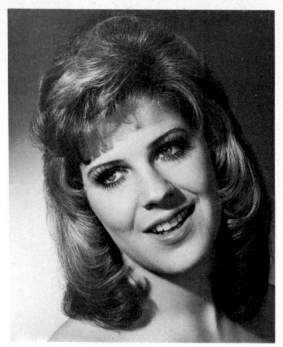

Fig. 31A *A picture taken without any soft focus attachment.*

B *The same negative printed with a soft focus attachment.*

C *A portrait printed with a canvas screen in contact with the negative.*

D *Printed through a linen screen placed in contact with the paper.*

is a positive advantage as well as being appropriate. Soft focus has been so abused in recent years, probably as a reaction to the biting sharpness of modern lenses, that there is a lot to be said for using a very large aperture instead. By doing this and focusing on the eyes, as one always should, the rest of the face will be very slightly out of focus and this will soften the skin tones and reduce texture.

It must not be forgotten that slight blemishes on a beautiful or interesting face may go unnoticed in the flesh but they will become painfully obvious in a very sharp photograph. The difficulty of retouching the small negatives so popular today, not to mention transparencies, justifies some softening of the image but it should only be employed when necessary and where appropriate to the subject.

Fog attachments

Another lens attachment which is designed to glamorize by subduing detail, softening the image and giving an almost ethereal effect is the fog diffuser. It looks like a piece of ground glass and there are several densities available to give various degrees of softness.

These attachments are much favoured by fashion and advertising photographers who have probably been influenced by their use on television, especially in the commercials. However, they are more acceptable with moving subjects on ciné film and they should only be used for still photography when they really enhance the subject. There is always a danger of overdoing it—and indeed this is already happening on television—but if a subject is beautiful it does not need soft focus except to create a special mood or atmosphere. For this reason, fog attachments are not really appropriate for indoor portraits but outdoors they can sometimes give a more attractive look to the background of a portrait.

Star attachments

A somewhat unglamorous subject can sometimes be given a touch of glamour by enhancing the environment or presentation rather than the sitter herself. For this purpose a star attachment which, like the other gadgets described, fits over the front of the lens can help. It looks like clear glass except that it is engraved with very fine crossed lines, something like graticules. These have the effect of turning a very bright point of light into a starburst. Since it only acts on bright points of light it is best employed with contre-jour portraits when there is a rim of highlight around the head but it can also produce star effects on sequins or diamonds. It is rarely that the highlights on the face such as seen on wet lips, metallic eyelid paint or catchlights in the eyes will be bright enough to be affected.

Fig. 32 *True soft focus is obtained by using an attachment on the camera lens and it gives a more luminous effect than softening in printing. Compare this with the previous illustration.*

Grain for effect

The attachments described so far are subject to the whims of fashion but one technique that has been in vogue for a considerable time is that of deliberate graininess. Film manufacturers have spent untold sums of money on research to get rid of grain and they have been very successful, especially with the slower emulsions, but now many photographers are trying to put it back; and not without some success.

If the grain effect is slight it will look like faulty processing but when it is very exaggerated and obviously deliberately done for effect it is quite acceptable if the subject is suitable, and it will certainly suppress some of the subject defects like blotchy skin or freckles. In order to obtain the maximum effect a grainy film must be used, and in both black and white and colour this means the fastest film. In black-and-white work coarse grain will be produced by full exposure and over-development in conjunction with an ordinary MQ developer instead of a fine-grain type. Some workers advocate a contrast building developer instead of a straight MQ formula.

Since the aim is to show as much grain as possible it makes sense to confine its use to lighting that will show it up. This usually means high-key lighting with a low degree of contrast and minimal areas of shadow. It often helps to print on a contrasty paper and curiously enough this treatment seems to add glamour.

In colour, grain does not seem to be so attractive unless it is overdone to a very great degree. Even with the fastest colour films and under-exposure, coupled with extended development, the grain is not exceptional in a transparency and it can be quite unpleasant instead of effective. A compromise with colour prints is to use a screen in contact with the negative and grain screens can be bought in photo shops as well as screens giving pseudo canvas etching and linen effects. These of course can also be used for black-and-white prints.

Another way to get the grain to show either in black and white or in colour prints is to enlarge an extremely small part of the negative. This also means some loss of definition and it is not so effective unless the subject is bold in character and the negative is extremely sharp in the first place.

All of these techniques, together with lens attachments, are to a large extent superficial embellishments and the lighting must be right in the first place. It will be appreciated that the lighting is by far the most important factor in drawing the subject, creating the desired presentation, flattering the sitter and concealing defects. For this reason it is far better for a beginner to employ photoflood lighting instead of flash, in spite of the convenience of the latter, until he or she has thoroughly mastered the correct placing of the main light and fill-in light sources.

Fig. 33 *A grain effect produced by making a paper negative and printing through the back of it can look attractive in an idealistic type of portrait.*

9: Posing the Sitter

Close-up or full length—formal or informal—format—angle of the head—direction of eyes—camera level—introducing hands—to smile or not to smile—clothing outdoors—hats—full-length posing

THERE are many ways to pose a live subject and the first requirement is that the pose should suit the sitter and be in harmony with the presentation desired. It is important that as far as possible this should be decided before the sitting, in order to avoid losing the sitter's confidence or patience by experimenting with different poses as though uncertain of what will be right.

Obviously two things must be decided in advance. First, is the portrait to be a formal one with a somewhat static or dignified pose or is it to be a candid and lively projection? Second, is it to be a full length, three-quarter length, half length or head and shoulder close-up? Indoors, where the space needed to get good perspective is probably limited, a head and shoulder is the most likely choice but in the garden there is usually more scope.

Formal poses with rather low-key lighting and plenty of strong dark tones are often the best choice for men and sometimes even for old ladies if they have plenty of character, but a more light-hearted treatment will be appropriate for a young person, especially a glamorous girl. Children are best treated in a very active and lively pose with a full-tone scale. Formal portraits of children stiffly posed and looking dressed up for the occasion are unnatural and are best left to the local professional. They have a place, and in fact there is quite a demand for them but they show little of the subject's real character. In years to come they will show how the child looked but not how he or she behaved.

It is a very useful exercise to study good portrait photographs in books and exhibitions and to visualize which treatment best suits the person to be photographed. In fact a good book of portraits is an invaluable reference and it will enable the beginner to pre-visualize his portrait and thus have a clear course of action to pursue as soon as the sitter arrives. Nothing is worse than 'hit and miss' posing in which the subject is asked to move through a series of poses and attitudes until the photographer says 'hold it' when an effective pose is reached.

Fig. 34 *The formal approach to portraiture in which the pose is carefully thought out and arranged.*

As much as possible should be arranged before the sitting and it is wise to decide upon the format in advance so that the camera can be ready for an upright or an oblong format. This will not apply, of course, when a 6×6cm camera is used. In most cases an upright format is more suitable for portraiture, especially when it is desired to convey an atmosphere of dignity or strength but an oblong format can sometimes emphasize the serenity or repose of a feminine sitter, especially when an interesting landscape is seen in the background.

For all formal portraiture indoors the sitter should sit with the body at an angle to the camera. If the shoulders are 'square-on' to the lens they will appear artificially broadened and this is certainly not flattering, even to a narrow-shouldered man. In fact if his shoulders drop he will look even weaker and in any case a square-on view gives a very static look to the portrait. Very few great painters have ever adopted it. By placing a chair for the sitter at an angle of about 30° to the camera/subject axis, the best angle for the body will automatically be adopted from the start. In this position the head can be rotated through an angle of 100° or more and it can be tilted to right or left and to the front or back which, together with a large choice of camera angles and viewpoints, provides an almost infinite variety of aspects in which the head can be presented.

In formal portraiture the range might well be limited to turning the head towards the camera while keeping the body at a 30° angle but for candid work the dramatic and opposing angles will create an impression of vitality.

Formal portraits indoors

This is probably the easiest branch of home portraiture and it is certainly easier to visualize the whole effect—the pose, the lighting and the general presentation—in advance. The sitter can be told to look towards the camera and the only adjustments required are the small changes of lighting angle discussed in the last chapter to offset any obvious irregularities in the face or the shape of the head. If the picture is to be head and shoulders only there is little else to worry about in the posing as long as he or she is sitting comfortably but upright.

The chair provided should always have a back or the sitter will tend to slump and get round shoulders, but chairs with arms are usually a nuisance because the sitter will automatically make use of them. This tends to make jackets and dresses ride up at the shoulders and produce creases or a gap between collar and neck. The best shoulder line is produced when the hands are allowed to rest on the lap. Sometimes it is an advantage to place one hand on the knee and this should be the hand on the far side from the camera.

Many successful formal portraits are taken with the hands and forearms placed on a table and both the hands and the table top are often included. It is most important, however, that the table and the chair are at exactly the right height or the pose will be strained and the sleeves will be full of creases.

Fig. 35 *The informal approach in which the pose is more casual, the sitter is looking into the camera and is often smiling or laughing. The head should nearly always be at an angle with a vivacious subject.*

Fig. 36A top left *An effective or lively pose is obtained by the sitter facing away from the camera and looking back over the shoulder.*
B top right *Long hair can be arranged to hide creases in the neck and also to give some stability to the composition.*
C left *When the composition is inclined to look top-heavy an arm can be posed forward to provide a base.*

For nearly all portraits of this type it is an advantage to place the camera a little lower than the level of the eyes. This adds a touch of height and dignity, particularly in the case of three-quarter or full-length pictures when the head is kept near to the top of the picture frame. The low viewpoint can emphasize a weak chin so the sitter should be asked to tilt the head back slightly to make it stick out. Conversely, an over-square jaw can be reduced if the head is tilted forward a little, but these points should be considered in conjunction with the lighting described in the last chapter.

In all formal portraiture the axis of the features is vertical, or very nearly so, and it is only suitable for a sedate or mature character. It is right for an official picture of the Mayor in his robes but it would be quite out of keeping for an exuberant youth whose character would be better projected by a diagonal axis of the features with an opposing line formed by the body.

Informal portraits indoors

Posing for less formal portraits provides much more freedom but at the same time introduces more scope for error. It is not so easy to visualize in advance although the general effect should certainly be decided before starting work.

Once again it is wise to place the chair at an angle but for all informal pictures it is better to have the face pointing away from the camera as well, usually in about three-quarter profile. In this pose the position of the nose must be checked. It can look very ugly if it cuts through the profile of the far cheek and even worse if the tip of the nose coincides with the line of the cheek. It can be corrected by turning the head slightly more towards the camera or, sometimes, by tilting the head slightly downward.

If the eyes look straight ahead when the face is in three-quarter profile they will give a more formal appearance to the picture than if they look into the camera. It will also be necessary to include enough background to ensure that the sitter is not looking so directly out of the picture frame that the viewer is also led out of the picture. On the whole it is much better for the eyes, which are by far the most interesting part of the face, to be looking into the lens and apparently at the viewer.

For the same reason the eyes should never be looking down. This may be justified in a shot which is intended to depict thoughtfulness or some other mood but it then ceases to be a portrait that depicts the character and likeness of the sitter. The eyes are so important that it is an advantage not only to light them well but to get them as wide open as possible. This can often be achieved by tilting the head slightly downwards so that the subject has to open them wide to look up into the lens. Other considerations being satisfied, it is sometimes advisable to raise the camera slightly above eye-level in order to cause them to open still farther. The only exception occurs when the subject has very bulging eyes in which case the eyes should not be turned at too sharp an angle or an excessive amount of white will be shown.

The angle of the head in the picture space has an effect on the final result. The nearer it is to a diagonal the greater the impression of vitality because

a diagonal always suggests movement. It is not always advisable to tell a sitter, especially if he or she is nervous or self-conscious, to tilt the head this way or that because the reaction is to get very taut and usually to move too far. Often the desired pose can be achieved quite naturally by walking around the camera while keeping up a conversation. For example if the sitter is facing left and the operator walks a little to the left of the camera it is almost certain that he or she will tilt the head forward to listen or reply. If the photographer steps to the right of the camera while the sitter is facing left the head will probably be tilted backwards. This is an experiment every beginner should try and with experience he will find that it is possible to get almost any variation on a basic pose quite naturally and avoids the commands of 'look this way—now look that way—no that's too much' which can reduce a nervous sitter to a state of despair. If the head is turned too far it may produce unpleasant wrinkles or accordion pleats in the neck but these can often be reduced by tilting the head slightly away from the camera.

Tilting the head in opposition to the angle of the body, as already mentioned, helps to give an impression of movement or vitality but it is a mistake to think that the same effect can be produced by tilting the camera. This merely looks as though the subject is falling forwards because the body is tilted as well and, of course, it is impossible where a natural background is included.

The opposing lines produced by the angle of the head relative to the body can be augmented by opposing lines created by the direction of the eyes, or by the arrangement of the hair in the case of women, and in all cases by the introduction of hands. Long hair can be arranged to frame the face and in the case of a very round face can be used to cover part of it in order to make it look narrower. If it is allowed to hang down on one side it must be vertical. Tilting the camera so that it hangs at an angle in the final print will give an absurd effect. It is usually better to arrange it so that it falls over a shoulder and makes a graceful curve. This technique can often be used to disguise wrinkles in the neck or to make a short neck look longer. There should never be any gaps in the hair, especially when a light background is used and it is equally important to ensure that no odd strands are sticking out because they will show up badly against the background. They are almost impossible to remove from a print unless they are white against a very dark background, and in a colour transparency even this is impossible.

The placing of the hands in a portrait, especially a close-up, is very difficult unless the subject is naturally graceful. No hand must be nearer to the camera than the face or it will appear too big and will probably catch too much light. The fingers should always be extended but slightly curved and the hand is best turned sideways to the camera so that it looks long and elegant. All too often one sees otherwise good portraits spoiled because a hand looks like a bunch of bananas. If a forearm is included it should not be allowed to form a vertical line in the picture and ideally it should point towards the face with the wrist slightly bent. When a whole arm is included the elbow should be

104

Fig. 37A *Hands in a portrait must be treated with care. This one is too large because it is nearer the camera and it should have been darkened with a barn door.*

B *The hand does not distract attention from the face when it is darker in tone and kept behind it.*

C *This shows a bad posing of the hands which look like a bunch of bananas and are far too big.*

D *This is a more natural and more elegant arrangement and the hand is subordinate to the face.*

bent but not so as to form a right angle and an arm should never be allowed to drop straight down to the side.

If the sitter is at all self-conscious it is advisable to provide some employment for the hands. A cigarette or pipe is a bit hackneyed but if the subject is male and a heavy smoker this could help the character build up. Sometimes a female sitter can be pictured with a hand adjusting her hair or resting a chin on the hand while a male sitter could be removing his glasses. It pays to study the subject to find out if there are any characteristic gestures or habits that are not only typical but which will make him or her feel at ease.

When a hand is raised towards the face it often causes the shoulder to rise and this should be watched because the near shoulder should always be higher than the one farther from the camera. In fact, with a low camera viewpoint the shoulder can be used to conceal a wrinkled neck if it is raised enough.

Many female sitters are under the impression that if they throw the head back it will give a longer and more graceful line to the neck. This can be so in a very few cases but usually it looks strained and merely draws attention to the Adam's apple. A long neck always looks better when the subject is leaning forward a little, especially at a three-quarter angle or in profile.

The last thing, but one of the most important, to worry about is the expression on the face and that is bound up with the mouth. The beginner will usually ask for a smile but this is such a fleeting thing and often takes on a very fixed look—like a shot of someone walking that has one foot permanently poised in the air.

One of the worst expressions is the big grin with the head thrown back and showing gleaming white teeth, shining tonsils and flaring nostrils. This may be alright for an advertising poster but it has no place in true portraiture unless the sitter is a professional comic or an opera singer! Likewise, many portraits exhibit a smile that can only be described as grudging. The photographer has told the sitter to smile and so he or she has forced one with an effort or with resentment and there is no complementary smile in the eyes. It is far better for the photographer to keep up a conversation that interests the subject and smiles will then come naturally. This is where the short exposures facilitated by flash or a powerful photoflood set-up can be a real advantage. In any case the sitter should be asked frequently to lick the lips because this makes smiling easier and helps to offset the dryness produced by nervousness. As a bonus it often produces attractive highlights which are especially useful for glamour subjects.

It is wise to remember that some people smile easily while others rarely smile at all. With the latter it is more characteristic to portray them without a smile and it is a mistake to think that people cannot be happy or contented unless they are smiling or laughing. Their true feelings will be seen in their eyes.

The easy way to get a natural expression, be it serious or smiling, is to get

106

Fig. 38A *Horizontal formats are sometimes difficult to fill but the tilted head and the sweep of the hat have done so effectively.*

B *A somewhat dreamy expression with the sitter looking into the distance is complemented by the out-of-focus plant and the horizontal format.*

the model to relax and enjoy the sitting. It goes without saying that the room should be comfortably warm and it often helps to have a little soft, but not obtrusive, music in the background. More than anything, however, it depends on the photographer's ability to keep an interesting conversation going, and in the way he instructs the sitter. An instruction such as 'please tilt your head' only confuses unless it also says which way and the photographer must remember that he is facing the opposite way and seeing 'left to right' *vis-à-vis* the subject. The sitter should never be touched but always given clear and concise instructions so that he or she can carry them out and gain confidence. It is a mistake to walk backwards and forwards between camera and sitter as though undecided what to do. The presence of other people in the room is also a distraction that should be avoided if possible.

Posing outdoors

Informal portraiture is much easier in the garden not only because the lighting and exposure problems are reduced but because the sitter is much more relaxed in natural surroundings. Formal portraiture is not so easy because the subject would merely feel silly dressed in formal attire and sitting on a chair in the middle of the lawn, but dressed informally a keen gardener leaning on his spade will look natural, feel relaxed and be expressing something of his character. Clothing should not be such as to make the subject self-conscious. Bare shoulders are permissible for indoor glamour shots and, indeed, have the advantage of not going out of fashion but they would look quite wrong outdoors.

A portrait is always better if the sitter is given something to do, provided that it is natural to him or her and to the clothes being worn. A pretty girl in a party dress depicted mowing the lawn would obviously look absurd but dressed in a summer frock and smelling a rose she would look more natural although the result might be scorned today as 'chocolate box'. However, the opportunities are only limited by the backgrounds and by one's imagination.

All the points made about posing indoors—angle of head and body, camera viewpoint, inclusion of hands, etc.—are still valid outdoors but it will be found that people do these things more naturally and will require far less direction from the photographer.

Hats are not often included in indoor portraits because they conceal part of the head if worn, and they are probably only justified for formal portraits in uniform. Outdoors they are best left off for the same reasons except in the case of glamour pictures where a large picture hat can be effective to frame the face. It can, however, affect the posing and make the subject self-conscious unless she is used to wearing it, and it is a mistake to expect anyone but a professional model to feel right in someone else's hat. Some photographers and some clubs build up a collection of props such as scarves, bits of coloured chiffon, picture hats, sunglasses, cigarette holders and lobster pots, but after one try they are rarely used again by the same photographer. In the case of

clubs one sees the same props turning up in many people's pictures so often that they become clichés.

Another advantage of outdoor portraiture is that there is usually more room to manoeuvre and full-length shots are a possibility. Here again it is necessary to get a natural pose by giving the subject something to do. Nothing is worse than the rigid vertical of a figure standing upright and obviously told to 'stand there'.

Posing a full-length figure creates a few more problems because the arms and legs are included. In some activities they may look naturally graceful, but when they do not, a compromise can be reached by making sure that the background appears dark. Patches of light between arms and torso or between the legs will emphasize any ugly angles or right angles.

A pretty girl can be posed gracefully on a garden seat with her legs together so that her whole figure makes a diagonal line. This is much more attractive than the more common shot of a girl seated in a swinging garden seat with legs apart, foreshortened, and forming two ugly vertical lines to dominate the picture. As far as possible, female legs should always be together and, when the subject is seated, placed at an angle, while men in trousers are often better shown in the more solid and stable pose of legs apart.

Here again a study of good photographs is of great benefit. Examples of outdoor portraits are not so easy to find in photographic reference books or in exhibitions but the advertisement pages of magazines and the editorial pages of fashion books can stimulate the right ideas. It is worth cutting out good examples and keeping them in a scrapbook for consultation before a sitting or an outdoor session. Sometimes it is useful to show one to the sitter rather than trying to explain it in words. Most subjects are more co-operative when they are able to understand exactly what is wanted.

10: Special Subject Considerations

Babies in arms—2–3 year olds—young children—domestic pets—theatrical subjects—self-portraits

MOST of the advice given so far has been in general terms and it will apply to the average adult male and female sitters. However, there are some subjects which demand special treatment and these are principally babies, pets, theatrical subjects and self-portraits, all of which require a different approach.

Photographing babies under 9 months

There is a big difference between photographing a baby which is still too young to sit up and one that has already started to crawl or totter about. Since the very young baby is virtually static it is easy to arrange a suitable background. Unless the mother is to be included it is only necessary to arrange a white sheet on the floor or on a low bed and shoot from above. The baby should also be dressed in white or light clothing and it is then possible to make a high-key photograph with delicate pastel tones either in colour or black and white. This treatment is very appropriate for the subject.

The baby will be looking up towards the ceiling so any lights directly above must be avoided or switched off, otherwise the infant will squint. Contrary to what a lot of people think, the lighting for high-key does not have to be on the camera/subject axis. The main light should be to one side to give good modelling and the high-key effect is produced by bringing the fill-in light close enough to reduce the contrast to a ratio of about 2:1. This means that most of the picture will be in pastel tones and the only really dark tones will be in eyelashes, the pupils or the hair if the subject is dark.

Nevertheless it is an advantage with very young babies to diffuse the lights by placing muslin screens over them or bouncing them from reflectors. The main light should be placed to one side of the sheet and about 4ft up if the baby is on the floor and the second or fill-in light should be as near to the camera/subject axis as is practicable. It will have to be much higher above

110

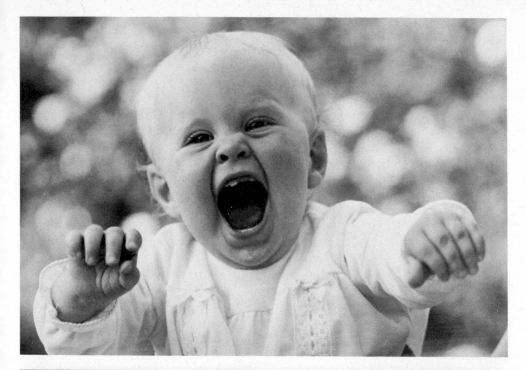

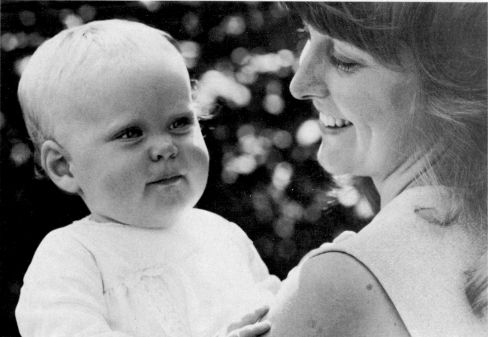

Fig. 39 *Babes in arms can be photographed alone if the mother holds the child out as in the upper photograph. On the other hand the inclusion of the mother often makes a more attractive picture as below. Note how a fussy background has been kept out of focus by using a large aperture. In the lower picture the baby's face has been illuminated by reflection from the mother's face and dress.*

the main light unless it is a weaker powered lamp. In effect the lighting should be as for a normal sitter but translated into plan.

With this arrangement a tripod is rarely necessary and the operator can stand astride or above the sheet and shoot almost directly downwards towards the baby. It goes without saying that the camera should be on a strap round the neck and the lamps should be carefully placed so that there is no danger of knocking them over. It is also important to ensure that filters and lens hoods are firmly secured, but in any case the operator should not stand directly over the baby's face. Sometimes it will be an advantage to stand to one side and slightly above the baby's head so that its eyes are fully open if it looks towards the camera.

A similar arrangement can be adopted if flash is employed. A baby is a most suitable subject for bounced flash, even if the gun is used on the camera with a reflector or bouncer as described in Chapter 3. In a small room it is usually sufficient to bounce the flash off a white wall or ceiling but the exposure required may be more than the largest aperture available, especially if working in colour. This is another occasion when an umbrella flash can be a great advantage because it concentrates most of the flash at a much closer point than a wall or ceiling.

The photographer will have to be prepared to take a lot of shots to get good expressions, or even smiles, and he or she should also be prepared to take a number of 'bracketed' exposures because accuracy is essential in a high-key shot. Under-exposure will mean a loss of the delicate gradation that there ought to be in the shadows and over-exposure will lose it in the all-important highlights which means that the modelling in the flesh tones will be lost.

A similar technique in posing can be adopted in the garden by placing a sheet on the lawn but this should not be done when the sun is bright because squinting will be unavoidable. An overcast sky is preferable and even then the baby should be turned so that it is looking away from the direction of the sun. Ideally the pictures should be taken in late afternoon when the sun is low and the baby's head points in that direction. If a helper holds a reflector —a newspaper will do—from above the baby's feet a nice balance can be achieved without discomforting the subject.

Sometimes a portrait of the mother holding the baby is required. A problem here is that there is a strong division of interest, especially if the mother is attractive. A good compromise is to include the whole of the baby's head and shoulders, but only to show a part of the mother's head. It is easy to arrange it so that the baby is looking towards the camera and the mother is in semi-profile looking towards her child. Another possibility is to photograph from behind the mother with the baby looking over her shoulder and this often produces an interested expression if the baby is wide awake. If the mother is photographed holding the baby so that they are looking towards each other, they should be turned in order that the baby can face the source of light and the mother is therefore darker in tone, thus giving dominance to the baby.

Taking the older baby

Babies up to 2 or 3 years old are more of a problem because they are usually very active and they quickly get impatient if they are told to stay in one place too long. The answer, of course, is to keep them interested. A mother who walks all round the room calling to the child, waving a rattle or a toy is usually a nuisance, and if she insists on making noises it is better for her to stand behind the operator.

One of the best professional child photographers of all time was the late Marcus Adams and he had his camera and himself concealed in a huge doll's house with the lens behind one of the windows. When he was ready he would pop a glove puppet out of one of the windows, make an appropriate noise, and quickly withdraw it. The child would wait with interest and anticipation for it to appear again. This arrangement is hardly practicable for the amateur but it demonstrates that it is an element of surprise which catches and holds a child's attention and keeps him or her captive enough to give time for focusing, and it will always provide an interested expression.

A good child photographer will therefore be on the look-out for novelties in appearance or in sounds and he will have more than one standing by because a child will soon get bored by one dodge after the surprise has been sprung. Familiar things like mother making clucking noises will have little effect. Another way of keeping a child captive is to give him or her something constructive to do like putting some toy bricks together, or dressing a doll. A lot will depend on the operator's personality but, above all, he must be quick and have everything ready in advance so that a maximum number of shots can be obtained before boredom sets in.

Most children up to a few years old are at their liveliest at bath-time and this is where the amateur can do better than the professional in his studio. In a small bathroom there is usually so much ambient reflection from mirrors and tiled walls that the substitution of the normal light with a photoflood lamp is sufficient. Portable electric lamps should not be taken into a bathroom.

If the bath is white or light in colour there will be enough reflection to avoid any dark shadows and exposures will usually be short enough for the camera to be held in the hand, but if colour film is being used the bath should preferably be white. A green bath could only produce a green baby!

Young children

Children between 3 years and 10 or more when they start to be co-operative with a photographer, are at their most mercurial and often most difficult. To ask them to sit and pose for the camera is often the equivalent in their minds of a visit to the dentist's surgery so it is better to face facts and depict them in their normal play or pursuing natural interests.

This type of picture shows more of the subjects's character, and a shot of little Johnny climbing a tree in jeans and T-shirt is far more telling than one seated like little Lord Fauntleroy in his best suit with his hair carefully brushed by mother. The joy in his face that is so obvious in the tree shot will

113

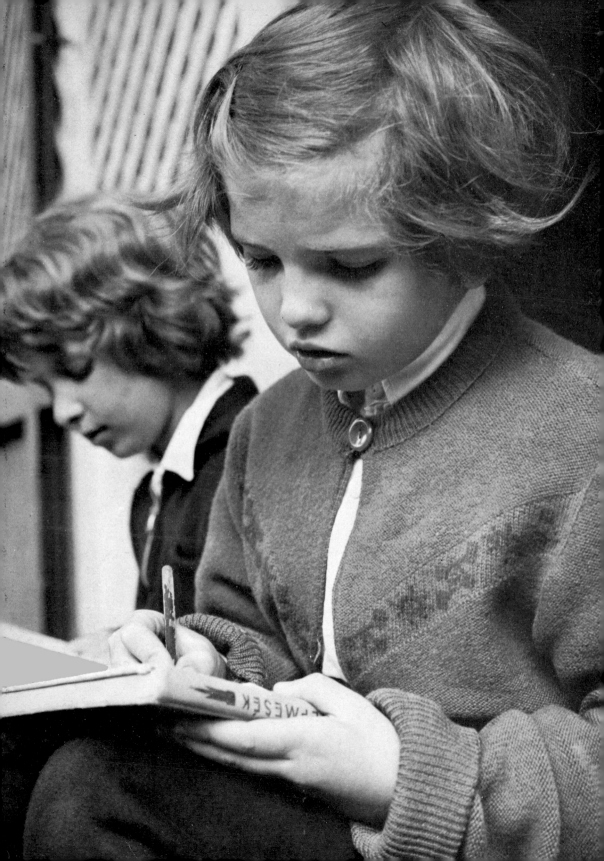

have changed to resentment in the studio or in the formal lighting set-up indoors.

Children in this age-group become very self-conscious when a camera is aimed at them, even in the garden, but after a while they will forget it if they have something to do. It is therefore better to have a little warming-up period to get to know them and for them to get used to the photographer. A long-focus lens is a help in throwing the background out of focus and also in keeping a reasonable distance from the subject. Very often it will pay to take a number of 'shots' by releasing the shutter without winding on the film and it can be done on some cameras by holding down the re-wind button while operating the winding lever. This will cock the shutter but not advance the film.

Indoors or outdoors a child must have something interesting to do and the photographer should give some thought to this in advance. Usually the garden will provide an answer if it has a goldfish pond, a slide or swing but, whatever it is, it should be fixed in place or the child will run away with it and the camera will require constant re-focusing. When there is a danger of distracting backgrounds, as there often is in a small garden with fences and flower beds all round, it is better to shoot downwards so that the lawn forms the background but, generally, it pays to get down to the child's level. This is often regarded as funny and will produce some laughing expressions, but it will also avoid distorted perspective.

Indoors it often pays to arrange the subject at a table on which he can do something constructive or interesting and it is then possible to place the lighting in advance and to ensure that a plain wall forms the background. This nearly always works with girls and boys who are interested in drawing or painting, but the camera must be kept low or the faces will not be fully visible unless they look up suddenly. It is likewise important to ensure that the painting or other object of interest does not become too obtrusive and it might be better slightly out of focus. It is worth noting that a painting or a book can make a useful reflector and on occasions can give a nice luminosity to the face.

Taking the family pet

Dogs, cats and other domestic animals vary enormously between the bulldog who will sit patiently without blinking an eyelid to the poodle puppy or kitten that simply won't sit still. Portraits of the more supine animals are easy because they can be treated, indoors or outdoors, just like adults. The lively breeds, however, can be very difficult and their habits must be studied. The owner will know when the pet is most amenable and this is often after a meal although sometimes a hungry animal can be induced to beg or show very lively expressions when a titbit is held close to the lens.

Fig. 40 *Natural pictures of older children are more easily obtained by giving them something to do and they will soon forget the camera.*

In most cases, however, the animal will leap forward rather than stay and look at food held some way in front of it. Many animals who are not hungry can be persuaded to stay on the same spot if it is warm. Placing a hot water bottle under a blanket will encourage a cat to sit on that spot and to stay there. Likewise, the top of a TV set which has been running long enough to get warm can provide an attractive platform and it is easy to pre-focus on this if the camera is on a tripod.

The bug-bear of 'red eye' caused by reflection from the retina of the eyes has already been mentioned. This occurs when flash is used on the camera. The main light should in any case, be well to one side because it is essential to bring out the texture of the fur. If flash is being used the fill-in should be placed at least a few inches above or below the lens. Modelling and the exact placing of the main light in order to flatter or to avoid bad nose shadows and so on, is not as important with animals as with humans so flash is probably better than photoflood lighting because of its other advantages.

This is one subject where direct flash can be justified because its hardness will make the most of the fur texture, but a fill-in or at least a large reflector will be essential. Often a nearby wall can serve as the reflector. Flash does not worry animals and most of them do not seem to be aware of it at all but they become restless and start to pant under strong photoflood lighting.

Animal photographs should as far as possible be taken at eye-level and this is a good reason for placing them on a table rather than crawling on the floor with a camera. Most of them will think it is a game if the photographer is on the floor which, to them, is an unnatural phenomenon. It is not an easy position for getting the eye to the viewfinder except when a twin-lens reflex is used but a table permits the use of a tripod and pre-arrangement of lighting and background.

With all but the largest animals a long-focus lens will be required to get a full-size image on the negative and a 135mm lens on a 35mm camera is usually the most convenient. With a tiny kitten it may be necessary to use an extension tube or bellows. It also pays to use the fastest film possible in order to keep exposures short while using a small enough aperture to ensure crisp definition. Very few lenses give maximum performance at the largest aperture and have to be stopped down to about f/5·6 to achieve the best possible rendering for the fur texture.

The exposure problem is not so acute outdoors as indoors but on the other hand it is usually more difficult to get pets to stay still when they are in the open air. An overcast or hazy day is better than bright sunlight, especially for colour pictures, and early morning or late afternoon is better for warmth and modelling. In the middle hours it is difficult to avoid the animal's back from being overlit and the head and sides from being in shadow. A further advantage of the early and late hours is that backlighting is often made possible and an outline of light around the animal, especially a white one, will always be more attractive than frontal lighting.

The hardest part about pet photography is undoubtedly getting the model's

co-operation and this means studying its habits, getting it to accept the photographer's presence, and making the right sounds. An unusual noise will always alert an animal but normally only once so it is well to have a variety of items such as clickers, bells, rattles, mouth organs, etc. to hand and they should only be operated by the photographer, and then only when he is ready to fire. Nothing is worse than the owner or others calling from different sides of the room while other sounds are coming from the camera position. It rarely pays to dangle food in front of the subject because he will try to get at it but if a tit-bit is given to him after a successful shot he might in time learn to associate the camera click with a reward and thereafter become much more co-operative.

One way of getting a cat or dog to sit still for a few seconds is to rub something tasty like bacon fat or liver on its jaws. It will almost certainly sit down to lick it off and this can make a nice picture as well as a shot showing a look of satisfaction when he has finished. If two puppies or kittens are photographed together a little 'tasty' rubbed on one animal's ear will cause the other one to lick it off and this could also make an attractive picture.

In the end, however, it is patience and a real love and understanding of animals that will produce the most consistent results, but everyone is giving himself a better chance by as much pre-arrangement as possible so that the technical requirements do not obtrude into the session. One can then concentrate almost entirely on the subject.

The theatrical sitter

Occasionally the opportunity may arise to portray an actor or actress in costume, especially if the photographer has any connections with the local amateur dramatic or operatic society. In such cases it is important to remember that the object is not so much to portray the person as the character he or she is playing. This means that the lighting and the pose should be appropriate to the character.

An obvious example is that of Dracula. A static portrait by normal lighting would have little impact even though the costume identifies the character. On the other hand, if he is depicted with a pose showing both hands like claws reaching towards the camera and his head right at the top of the picture as if about to pounce down on his victim the effect will be more realistic. It will also demand that the main light be placed well below the subject and near the camera/subject axis. This form of lighting gives an extremely sinister effect. In most cases a low camera viewpoint will enhance the dramatic atmosphere and will be likened to a view from the front stalls. It is justified here but that's the only time that a main light should ever be below the subject.

With this type of subject the background should be very dark but in other cases, especially of beautiful heroines, a dark background may not be appropriate and since one has not got stage scenery at home it is wise to keep the background area down to a minimum in the picture space. On the stage, spotlights, rimlights and footlights cast shadows and form multiple highlights

so this is the one type of portraiture in which artificial highlights can be tolerated and in fact are almost essential to give the right atmosphere.

An overhead boomlight and one or more auxiliary lights placed behind the subject to create highlights on the sides of the face and shoulders are almost essential if theatrical photography is to be undertaken at home instead of on the stage. These highlights can be enhanced by the use of star filters which add to the theatrical atmosphere. More than anything however, it is essential that the subject acts the part and takes up a pose that he or she would naturally adopt on stage. This should not be difficult, especially if the sitter is asked to rehearse a short extract from a significant part of the action. It will readily be realized that theatrical portraits out of doors would be unnatural and theatrical lighting would be impossible.

Self-portraits

No special apparatus other than that used for normal portraits is required for self-portraits at home. These can be taken in a mirror, but the difficulty of avoiding reflections and unwanted highlights, as well as a faint double image caused by the thickness of the glass, rules out this method unless one wants to be seen actually using the camera.

A much easier way is to set up the camera and the lighting as if photographing another person. Focusing will have to be done by measuring the distance from the centre of the chair to the camera and setting this on the lens, while using a small enough stop to ensure at least 15 inches depth of field. An alternative would be to place a torch where the face is likely to come and focus on that. The shutter is fired either by using the delayed-action device on the camera or by employing a long cable release. The rubber-tube type with a squeeze bulb is the most reliable when the distance is more than 2 or 3 feet as it is almost certain to be. The bulb can be pressed by foot if the hands are to be included in the picture.

Another way would be to open the shutter on 'time' in total darkness and then fire a flash by cable release or remote control. This requires a shutter that has a 'time' setting or a cable release with a locking device if there is only a 'bulb' setting. However, this is not a very advisable course because of the danger of knocking things over or missing the chair.

In either case, bounced flash is advisable, preferably via an umbrella, because its softness will insure against the ugly shadows that could occur when using photofloods or direct flash because of the impossibility of placing the main light exactly.

11: Composing the Portrait

Placing the head in the picture space—directional lines—triangular forms—tone distribution—background tone—colour juxtaposition—colour harmony

THE composition, or design, of a picture is simply the arrangement of all the elements so that they form a harmonious whole. This implies an achievement of unity or completeness so that the picture is complete in itself and does not look like a fragment of a larger scene. Within the picture frame the arrangement of lines, tones and colours should be such as to encourage the viewer to absorb all the features in an orderly progression.

There should always be a principal point of interest that will catch the attention first and in a portrait this will be the eyes. Therefore the eyes must be placed in a favourable position and no other feature may have a stronger attraction. It might be thought that nothing could be more attractive than the eyes and in life this is so but many a portrait has been spoilt because the eyes were badly lit and a patterned dress or a breast pocket handkerchief was better illuminated.

Some people find it difficult to decide on the best position for the head in a close-up portrait. In black and white there is a certain latitude because there is plenty of facility for trimming or cropping in the enlarger, provided enough background has been included. With colour transparencies it will be necessary to compose the picture in the viewfinder, and this in any case is a salutary exercise. There is a temptation when trimming prints with the aid of 'L' shaped masks to keep on cropping until one is left with little more than the eyes, and the purpose of the portrait has been defeated.

A simple way of planning the composition is to imagine a line running through the eyes and another crossing it at right angles through the nose and chin. This forms something like a cross and its placing in the picture space to provide a good balance is fairly easy to visualize.

This cross should never be placed centrally with the intersection in the middle of the picture space, nor should the lines be running horizontally

and vertically. The effect will be static and much too symmetrical. To provide a good balance, the intersection of the cross should be well off-centre and near one of the four points of intersection that occur if the picture is divided into nine equal sections by two equally spaced vertical and horizontal lines —called by photographers 'the intersection of thirds'. Usually, of course, the eyes in a portrait will come near one of the two upper points rather than the lower.

The cross should come to right or left of centre according to the direction in which the subject is looking. If he or she is looking towards the left there should be more background on the left in order to prevent the viewer being led out of the picture, so the cross should be to the right of centre. Conversely, when the eyes are looking to the right, the cross should be left of centre and the more the subject is looking away from the camera the more the background necessary on that side, reaching a maximum for a pure profile shot.

When the sitter is looking into the camera, the cross should still be off-centre, although just a little may suffice and the side to choose could be decided by the direction in which the shoulders are facing because these, as already mentioned in Chapter 9, should never be square-on to the camera.

An upright cross, whatever its position in the picture space will look very static and it should be reserved for formal portraiture which is often three-quarter or full length rather than head and shoulders only. In such cases the cross would normally come very high in the picture. In order to introduce some movement or vitality into a portrait the cross should be tilted. If it is tilted forwards a little it will show just enough movement to be interesting but tilted backwards it will show enormous vitality, akin to someone throwing back the head to roar with laughter. It is always useful to remember that horizontals and verticals are static and diagonals suggest movement.

Directional tendencies

Portraits, whether three-quarter length, half length or head and shoulders only, will be better for an arrangement that suggests a triangle or pyramid because this form has stability. When planning a picture it helps to imagine the subject posed so that he or she fits into a particular type of triangle because the right choice can assist the impression of the subject that it is desired to convey.

For example, a tall triangle conveys height and dignity and it is appropriate for a formal three-quarter length portrait, especially in an upright format, but in an oblong format it could suggest struggle or confinement. Conversely a low or flat triangle suggests great stability, especially in an oblong format but in an upright format it can give an impression of weakness. When the triangle is tilted forward a little in the direction the sitter is facing it will suggest movement and, tilted backwards, it will suggest liveliness and vitality. However, tilting the triangle so far either way that it appears to be falling over will suggest instability and lack of balance so it should not be employed

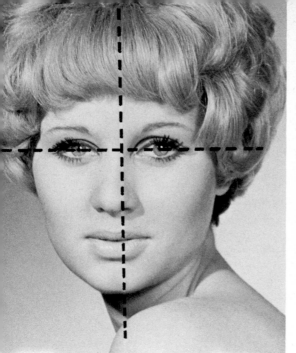

Fig. 41A *An easy way to decide on the placing of a head in the picture space is to imagine a cross through eyes and nose. It should not be dead centre as here.*

B *The cross can be upright for formal portraits but it will give vitality and movement when off centre and tilted as in this portrait.*

C *When the eyes are looking out of the picture and close to the edge the viewer's eye will follow them and be led out of the frame.*

D *The remedy is to allow plenty of background in front of the face or put plenty of dark tone into the background.*

unless it has some support in the form of opposition lines or heavy tone masses. The least interesting form is the equilateral triangle.

This is a convenient way for the beginner to visualize a composition but it is not essential that there should be obvious and unbroken lines although there should be directional tendencies made up of accents, tones, lines or points of attraction which the eye will automatically follow. There can be breaks as long as the eye can skip them easily and, in fact, such breaks can provide variety and interest. The directional lines can also be purely imaginary and an example of this lies in the way that the viewer's eye will always tend to follow the direction in which the subject is looking. This can be more powerful than an actual line in the picture so it is of great importance in portrait design.

The actual nature of a line can also be emotive. The artist, Hogarth, said that the most perfect line is the curve which resembles the line of a woman's back—a sort of extended S curve—and there is no doubt that it suggests beauty and grace. On the other hand, straight lines are uncompromising and suggest strength, force or vitality.

In portraiture this is something which must be considered when posing the subject but it has a bearing on composition as well. In a triangular or pyramid form there is sometimes a tendency for straight lines to be suggested by the arms with sufficient force to encourage the eye out of the picture. It must be countered by opposing lines and this can often be achieved when the arm is resting on a table, the lines of which run counter to the lines of the arm, and sometimes it can be countered by a heavy mass of tone.

Directional tendencies can also be created by the position of tones. It is a fact that the eye is always attracted to light tones more than dark tones, other things such as size being equal. Therefore if there are two or more light areas in a picture the eye will generally travel from one to the other and the order can be controlled by a progressive darkening from area to area or a progressive reduction in size.

Put into practical terms it means that the face in a portrait, which ought to be the principal attraction, should be lighter and probably greater in area than the hands if they are included. Any other light-toned areas such as clothing should be still further subdued. A very frequent fault in portraiture is in having the hands too prominent, usually because they are lighter than the face.

Another very common fault is to have the background so light that it dominates everything else and, since it extends to the edges of the picture, the sense of completeness is lost. If for any reason the subject is darker than the background, the latter should be kept to a minimum or darkened towards the edges to form a 'frame'. It is usually better in portraiture to take a tip from the old masters and show the subject much lighter than the background in all but high-key or glamour portraits.

The control of tone balance in black and white

For a picture to give satisfaction it must look balanced and one which has all its light tones on one side and all its dark tones on the other will produce a vague feeling of uneasiness in the viewer. This does not mean that a picture must be symmetrical in its tone arrangement—that can be boring—but if one can imagine the tones of the subject translated into equivalent weights the picture should balance on a fulcrum point on or very near the centre. This can apply whether there is a bold tone scheme with large areas of tone masses or a more complicated design with small areas of light and dark tones interspersed all over it.

Apart from the balance of tones, consideration has to be given to the emotional note that is projected by differing arrangements. The tone scheme can be made to convey vitality, gloom, strength, weakness, dignity or gaiety, so it should always be matched to the subject. Obviously, light tones, well broken up and with a lot of interchange can complement a lively child portrait while a very dark tone scheme will be more appropriate for a sad old man. Likewise, bold tone massing, predominantly dark, will add strength to a square-jawed tycoon and very light tones, well scattered in a high-key portrait will emphasize the weakness and helplessness of a new baby.

Whatever the arrangement, it is important to ensure that no very light areas of tone appear on or near the edges of the picture frame. Brilliance is not obtained by using a large area of light tone—a tiny area of light in a large area of dark tone will look brighter and have more impact than a large area of light tone. Therefore a very small area of light tone in the background or near the edge can be distracting.

This phenomenon can be turned to good account in expressing vitality. Maximum force is obtained by placing the brightest lights against the darkest tones although it can also lead to 'spottiness' if over-done. Movement can also be emphasized if the diagonal 'lines' already mentioned are treated in the same way in terms of tone.

Conversely, avoidance of the sharp contrasts obtained by the direct juxta-position of light and dark tones can produce a quieter or more restful mood. This is done by interposing middle tones between the masses of light and dark and by restricting any contrasting parts to a small portion of the total picture area. Areas of tone which virtually 'melt' into each other convey repose.

Background tone

The overall tone of the background should be decided, as already stated, according to the type and character of the sitter as well as the mood to be expressed. However, nothing is more boring than an even tone all over and some variation of tone is required in order to give it interest, but this must also be considered in relation to the general tone composition.

For example it must not have any tiny areas of strong highlights, especially if the background is dark, or the result will be spotty and distracting. If they

123

Fig. 42 *There are occasions when all the rules of composition can be broken to good effect but it is wise to make sure of a good likeness by conventional means and then have fun with the unusual.*

Fig. 43A *Tone balance is essential in a black-and-white picture. With a light background this would have been unbalanced but the total weight of the background tones just about balances that of the head.*

B *Pictures can often be improved by cropping and two L shaped pieces of white card help to decide what to cut off. Practice at this is a useful exercise in composition.*

are unavoidable they should be so much out of focus that they melt into the surrounding areas. Likewise the background should always be lighter where it is adjacent to the subject than it is at the edges so that there is a framing effect. It can, if necessary, be achieved by shading during enlargement but this never looks as satisfactory as the variations produced by separate lighting for the background. It is usually unwise to allow the background to be lighter at the base of the picture than elsewhere because this can destroy stability unless the shoulder or the body is clothed in something dark and arranged so that it spreads across most of the lower edge of the picture.

Very often it is an advantage to integrate the subject with the background by an interchange of tones, and when in doubt about the background tone it is a good course to adopt. It simply means that the lightest tones of the subject should appear against darker tones in the background, and the darker tones of the subject should be adjacent to lighter tones in the background. In practice this would mean that the side of the face in a three-quarter shot, which would naturally be well lit, should be seen against a darker tone while the hair on the other side should come against a dark tone. This is a more satisfying arrangement than when both sides of the head are darker or both are lighter than the background tone.

This can also apply vertically so that the dark tones at the shoulders if they are covered in dark clothes come against a lighter background than the face and it could also apply to dark hair, but if the shoulders are bare and the hair is blond the reverse would apply.

All these 'rules' may seem to be a rather mechanical approach to composition but a lot of film is wasted because photographers start a sitting without previous thought and just juggle about with lights, posing and background in the hope that everything will turn out all right. It is not suggested that the guidelines given here should form rigid rules but they should help the beginner to develop an appreciation which will avoid disappointment with his or her early efforts and lead to more creative and original work later. Sir Charles Holmes, an art critic early in this century wrote—'Canons and formulas have been worked out by great artists, but no great artist has ever allowed the powers of expression to be hampered by such . . . or has employed them except as a convenient mean from which a significant deviation could start. Each artist must prove his originality by deviating from the canons of predecessors in search of new and slightly different modes of expression.' He might have added that the beginner must learn the canons and formulas before he is able to deviate from them successfully.

Composition in colour

For portraiture in colour many of the principles of line, form and tone massing still have a part to play in the composition but it is necessary to consider colour harmony and the behaviour of colours as well. Often, this should be the first consideration because colour alone can dominate the picture.

Strange as it may seem, the first consideration in colour portraiture should be the background. A wrong choice of hue can spoil a picture in three ways; it can destroy the impression of depth that any good picture should have, it can create the wrong mood and it can clash with the colours in the subject.

It is a fact that all cool colours such as blues, purples and blue-greens appear to recede, while warm colours like yellow, orange, red and yellow-greens appear to advance. This is probably a psychological factor associated with the natural coolness that occurs in a distant landscape whereby greens which are yellowish in the foreground appear to the eye as blue on the far horizon.

Because of this it is an advantage to have the background of a portrait in a cool colour. The warm colours of the face will then stand out against a background that appears to recede into the wall, thus giving a three-dimensional effect or an impression of depth. This phenomenon is frequently employed by portrait painters who follow the old masters in having a very dark green or brown background, but dress the sitter in scarlets and gold.

Colours create moods, largely because of their associations, and the depth of the colour can also have its effect. An intense or saturated pure hue can be very powerful but a pastel tint of it does not necessarily produce a weaker version of the same mood—it may project a new mood of its own. Likewise secondary colours and hues degraded with grey can produce moods and reactions of their own, but all are effected by their reactions on each other. This means that the juxtaposition of lines, tones and tints is very significant in the make-up of a colour portrait.

To quote an example: a baby with blond hair and a pale pink face against a pastel blue background will make a pleasing picture, especially if the contrast of the lighting is low so that an overall high-key effect is achieved. On the other hand if the baby has black hair it will show inherent contrast which is out of keeping with the overall impression, so a blue-green or mid-green background would probably be better although it should not be as dark as the hair and should still be light in tone.

At the other extreme, elderly people are usually better rendered in darker colour schemes but not in such pure colours. An old lady would look well against a cool dark green background which would harmonize well with dark red or brown clothing, while white or light grey hair would look well against this colour. For an elderly man a sombre brown-black or dark sepia is appropriate, especially if the lighting on the subject has been kept fairly contrasty in order to bring out character and texture. Such subjects usually wear rather subdued greys or navy blues so an intense hue anywhere in the picture except the face would draw too much attention to itself.

For young men and women, brighter and more contrasty colour schemes are appropriate but they should be in keeping with the mood. For formal or static poses the colours need not show such intensity or contrast as for gay laughing or action poses. It is fairly safe to use blue in the background for

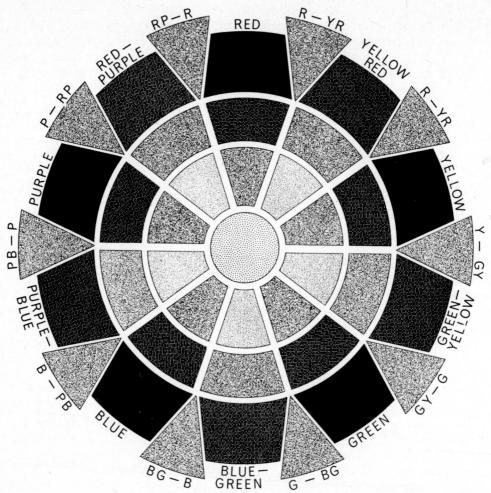

11 An adaptation of a colour wheel devised by Professor Albert H. Munsell. If the subject is in one of the primary colours shewn in the outer wheel the colour immediately opposite will provide a harmonious background. Likewise, if the subject is in one of the secondary colours in the outer circle, the opposing pure colour can be used or vice versa. Tertiary colours will also harmonize with the opposing tertiaries and in all cases the immediately adjacent colours to the latter provide possible alternatives. In general it is better to match a primary with a secondary or tertiary in order to provide contrast. Two primaries together would tend to fight or cancel each other out and two tertiaries together would look weak. The inner circles represent tones (i.e. degraded with grey) of the outer ring of pure colours.

blondes and blue-green for brunettes, and they can be almost pure hues instead of pastel or greyed down tints.

Children and young women can be satisfactorily portrayed in the garden, using the sky as a background if it is not overcast. In other cases it is better to work indoors unless dark green or dark brown backgrounds are available outside the house. Indoors, there is more control over the colours and one is able to introduce more variation of tone in it. This is even more important than in black and white; an overall tone in one colour can be very monotonous.

Having decided on the right background colour to suit the type of sitter it is necessary to decide what other colours are to be introduced to convey the overall mood. Warm colours generally produce a welcome and pleasing reaction while cold colours produce a slightly adverse reaction when they are dominant. Also, many colours produce certain sensations by the association of ideas. For example, certain hues of green convey a macabre or mysterious atmosphere, purple may look funereal, crimson may be regal, blue suggests distinction, yellow is reminiscent of sunshine, pink of health and so on. This means that the harmony and unity of a portrait can be destroyed if the mood conveyed by the colours does not match the subject. A sweating labourer in pastel blue would look as absurd as a baby in a purple robe. The intensity of colours also has a profound effect on mood and the more intense they are, the greater the emotional impact; deep tones symbolize strength and pastel tints suggest delicacy, sentiment or romance.

In planning a colour composition it should be borne in mind that some colours, when placed side by side, have a bad effect on each other and strike a discordant note while others appear to give life and emphasis to each other. Some even appear to vibrate—a phenomenon which was much exploited by the Pointillist painters. It is rarely wise to have pure and intense colours adjacent to each other. This may be effective for an advertising poster but it is too vulgar for a portrait. Since pure colours inevitably have a stronger attraction than their tints, as well as secondary and tertiary colours, the ideal composition will generally consist of a pure colour in the principal subject and secondary or greyed down colours in the other elements.

From this it is obvious that much more thought must be given to the clothing to be worn for a colour portrait than for a black-and-white version. Colour harmony is largely a matter of personal taste and aesthetic judgement, but to assist in the advance planning the colour wheel reproduced on page 128 can be consulted. It is a simplified version of one devised by the late Professor Munsell. Colours which are adjacent to each other in the diagram will clash with each other, even to the point of vibration, but those from opposite sides will usually harmonize.

For example, if blue-green has been chosen for the background, red will be suitable for the clothing or other props. Orange would also be a good choice but yellow-green or purple would clash violently. If the clothing is in a pure colour the background colour should be chosen from the *inner* ring on the opposite side. If it is impossible to avoid using two pure colours from the

outer ring, even though on opposite sides, the *area* of one should be much greater than the other.

When a subdued colour scheme is required, and this is often the case with older people, it is best to avoid pure colours altogether and take one for the clothing from the inner ring and one for the background from the *inside* ring. The colour of the face is unalterable but fortunately flesh is a mid-way colour and a tint that sits well between a warm foreground and a cool background while the high spots of deeper colour in the lips and eyes provide high spots which give contrast.

Some of the best pictures ever taken have colour schemes which are contrary to everything stated here but, as with the 'rules' of composition for black and white, the beginner will save a lot of time and expense by following the conventional guidelines described in this chapter until such time as he is able to depart from them with confidence.

12: Available Light Portraiture

North versus south windows—fill-in reflectors—fill-in flash—setting the subject distance—full-length pictures— portraits by room lighting—windows as background—two window lighting

ANY illumination that can be used to take a photograph is 'available light' but the term is usually applied to pictures taken indoors and, in the case of portraits at home, to those taken by daylight from a window. The effect of the latter is natural and pleasing and it certainly requires less apparatus. Many people consider that this makes the limitation to a few hours of daylight well worth while.

Daylight from a window gives a very soft effect but it does not, by any means, produce a flat picture. In a room with only one window there is a high degree of contrast and a fill-in light or reflector is normally necessary to reduce it.

Windows that face the sun are not very satisfactory because the light can vary in strength from moment to moment and constant adjustments to exposure and fill-in would be necessary. The more consistent and softer light from a window facing north is preferable. Also, sunlight can cast shadows of leaded light panes or bulls-eye glass on to the subject and generally give a harsh effect.

At a given distance from the sitter the softness of the light will vary with the size of the window. A very small window acts something like a spotlight, although not so hard, while a large window is more like a diffused floodlight. By masking a part of the window any desired effect can be obtained. Variation can also be achieved by altering the distance between the sitter and the window. The nearer he or she is placed, the softer the light because the area of the light source is relatively larger.

In order to have room to manoeuvre it is advisable to pose the sitter at least 5ft away from the window and placed well back so that most of the light is on the front of him and not behind. It will probably be necessary to mask

131

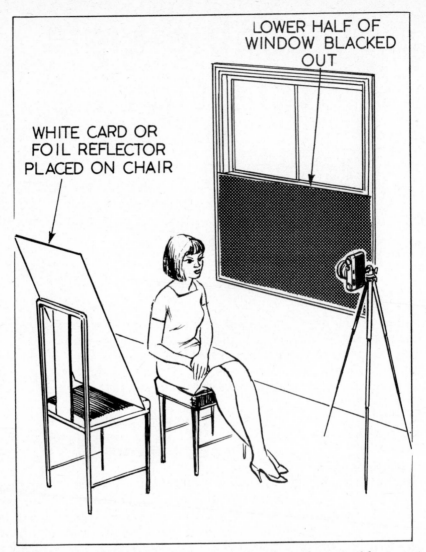

LOWER HALF OF
WINDOW BLACKED
OUT

WHITE CARD OR
FOIL REFLECTOR
PLACED ON CHAIR

12 *Blacking out part of a window will provide light at the angle required for portraiture.*
A reflector in the form of a large white card is usually sufficient to provide the required
amount of shadow detail and the overall contrast will be controlled by its distance from
the subject.

off the lower part of the window so that the light falls at an angle of somewhere
between 30° and 40°. Masking is particularly important in the case of full-
length windows or a lot of the modelling will be lost. A high window should
provide the sort of lighting used by Rembrandt and it is worth studying some
of his pictures and trying to copy the beautiful modelling that they show.
 Unless there happens to be another window on the other side of the room

132

the contrast provided by one window alone will be far too much for any film. The detail visible to the eye will certainly not show in the print if the exposure is correct for the highlights. A fill-in lamp can be used for black and white but unless it is very strongly diffused it will cast a harder light than the window, so the ideal fill-in is a white reflector of as large an area as is practicable.

When colour film is employed, a fill-in photoflood lamp cannot be used because it is the wrong colour temperature for daylight film and the shadow areas would appear much too warm. Flash could be employed but since it is impossible to see the effect in advance it requires a great deal of experience to judge the distance to place it for a particular degree of contrast. There is also the danger of casting harder shadows than the main light from the window.

If flash is used at all, it should be bounced off a large white reflector or an umbrella and it should be placed as near as possible to the camera/subject axis. Exposure should be measured for the daylight, and the distance for the flash calculated in the same way as for fill-in flash outdoors (see Chapter 7) although in a very small room it may be necessary to make allowance for the ambient reflection and reduce it accordingly. For example: if the meter indicates 1/50th second at f/8 and the guide number for the speed of film employed is 80, full illumination would be obtained with the flash at $\frac{80}{8} =$ 10ft. However, the flash is reduced by bouncing to about a quarter of its strength (2 stops) and the result would then show a contrast ratio of about 2:1, which is quite good for colour. To obtain greater contrast the flash would have to be reduced with one or more layers of handkerchief and each would probably cut it by about one stop. One layer should make the necessary adjustment for the ambient reflection in a small room.

In a small room it will not be practicable to place the lamp as much as 10ft from the sitter so further layers of handkerchiefs will be required and only tests can establish the best distance or the amount of reduction. If tests are made it must be remembered that the results will only apply when the window light is similar so adjustments must be made to the strength of the fill-in light if the daylight is stronger or weaker than when the tests were made.

On the whole, the beginner would be wise to gain experience by using a plain reflector rather than flash and a very useful surface is provided by a ciné or slide projection screen if it is a rigid free-standing type. Failing that, a large white card or mounting board can serve but it will be necessary to provide some means of adjusting the angle so that the light is reflected back from the window to the face. A handyman could easily devise an adjustable easel and a simple but effective arrangement is to use one or two Bowen's two-way clips and clamp one side of the clip to the back of a kitchen chair.

The tone of the background will depend on the tone of the wall behind the subject but it will obviously come out much darker than the face unless it is lit separately. If it has a patterned wallpaper, a background cloth as described in Chapter 4 should be put up and a lamp placed between it and

the sitter. With colour portraits, allowance must be made for the fact that they will come out much warmer than if they were lit by daylight or flash. This may be acceptable but if not a blue gel can be placed in front of the lamp.

The advantage of using a portable white or silver reflector, together with a photoflood, for the background is that the effect can be seen before taking. Some people prefer to use a gold-faced reflector in order to put some warmth in the shadows. This is a help if the window faces south and the light is direct or diffused sunlight, but if the recommended north light is employed, silver or white provides a better colour balance.

Full-length pictures

Full-length photography is comparatively easy by available light if there is enough room for the subject to stand far enough away from the window to be evenly lit. In this case it may not be necessary to mask off the lower half of the window. The softness of the lighting makes it appropriate for full-length figure studies as well. If an interesting background such as a wall tapestry or shelves of books is available and appropriate to the subject, daylight lighting is ideal because of its even spread and the absence of artificial shadows.

However, a fill-in light is certain to be required and a reflector may well be too small to give even fill-in illumination over the full length of the subject. This could also be a problem with photofloods unless two heavily diffused versions can be used, one to fill-in the top half and one the lower. Professionals often use a vertical bank of lamps in a painted trough for this purpose, but in a small room a possible remedy is to make a wall serve as a large reflector. If the subject is within about 6ft of the wall, one or more photofloods directed on to it will give an evenly spread reflection. Failing this, of course, one or more flashguns could be aimed at the wall, but the result cannot be seen until the print has been processed. On the other hand flash *must* be used if the picture is to be in colour. Likewise, the wall must be white and if this is not its natural colour a sheet should be hung in front of it.

Room lighting

Ordinary room lighting from chandeliers, ceiling fixtures and standard lamps is also 'available' light but it is unsuitable for serious portraiture because the lights are not easily manoeuvrable, especially to the angles required to give good modelling. Nevertheless, there are occasions when a photographer is expected to take pictures by room lighting, notably at parties.

One way of getting a reasonable picture is to replace the bulb or bulbs in a ceiling light or chandelier with photoflood bulbs. The subject should then be placed below the light but slightly behind and to one side of it so that the light falls on the face at an angle of about 45°. This will cause dark shadows in the eye sockets and under the chin because of the lack of a fill-in light so the subject should hold a book in such a position that the light will be reflected back on to the face. Alternatively, if a table lamp is available,

this could be pressed into service as a fill-in and a 100 watt or 150 watt bulb may be strong enough for this purpose.

If the ceiling is low, the fall-off in illumination may cause the top of the head to be overlit or the chin to be too dark, in which case the subject should be moved farther back. In any case the body will not be so well lit as the face, but this is unlikely to be a drawback, and could even be an advantage.

A table lamp could also be used to throw some light on the background with a plain surface but it would not be advisable on a natural background because it could not illuminate a large area evenly enough. For this work, if colour film is being used, curtains should be drawn over the windows to eliminate daylight which would come out too blue if Type A film (artificial light) is in the camera. Fluorescent tubes, if any, should be switched off, because they are unsuitable for photography.

Window backgrounds

Very attractive portraits can often be taken by including a window or part of the window in the picture. It is essential that there is some detail shewn in the window so the scene beyond must be reasonably attractive or kept well out of focus. Unless a silhouette portrait is required it will also be necessary to illuminate the subject artificially because the contrast between the outside light and the ambient room light on the subject will be far too great. The exposure, in other words, must be calculated for the light on the scene outside of the window and a fill-in light is then used on the subject to bring it into a contrast ratio that the film can accommodate. A white reflector will rarely be strong enough.

When using black-and-white film a photoflood light can be employed, but, as it will be the sole illumination for the subject if the sitter's back is to the window, it should be treated to some extent as a main light and placed to one side and a little above. On the other hand, if the subject is placed so that the face is in semi-profile and is partly lit by the light from the window, the photoflood should be treated as a fill-in and placed as near as possible to the camera/subject axis. It should also be a soft, diffused light as for ordinary photography and care must be taken to avoid any reflection of the lamp appearing in the window glass.

If the scene outside is not very attractive it should be kept well out of focus or, alternatively, a net curtain should be placed over the window. The latter softens the light considerably but it will not be very attractive as a background unless it is arranged in pleasing folds or unless the window has small panes or leaded lights showing through. The camera must be kept upright so that the folds in the curtains or the frames of the window appear absolutely vertical.

For colour photography it will be necessary to use flash and great care is necessary to ensure that it is not stronger than the light from the window. If it is, the result will look unnatural and the exposure for the flash so short that it will look like darkness or semi-darkness outside. It may not be possible

135

to light the subject to give good modelling without the exposure being too long for the daylight outside, in which case one can only try again, when the light outside is much weaker, for example, late in the day or when the sky is very overcast.

Two windows

When the room available for photography has two windows the task of lighting is made easier because there will be a considerable amount of ambient light and it may even be enough to provide fill-in illumination. Modern homes with a through lounge are ideal and the degree of contrast can be controlled by the relative distance of the sitter from each window. Even better is the room which has windows on two adjacent walls provided they do not go right into the corner. By placing the subject nearer to one window than the other contrast is very easily controlled because one window acts as a main light and the other as a fill-in. If one window is admitting light from a brighter part of the sky than the other, so much the better. The window which is used as a main light should have the lower part masked to give 45° lighting or thereabouts, but the other can be left as it is although a muslin or net curtain will ensure that it is completely shadowless.

In this situation an artificial background placed in the room is better than attempting to use a wall. This can be a ciné projection screen if it is big enough, and most of them are adequate for head-and-shoulder portraits. Since the cast shadows will be very soft the sitter can be placed quite close to the screen.

Failing this the far walls of the room will have to serve as the background and, unless they are uncluttered but interesting, it would be better to have them appear very dark in the print. In a large room this will be no problem but in a small room it will be necessary to have the sitter as close as possible to the window serving as the main light. It will also be necessary to watch that the angle between the two opposite walls does not set up a strong vertical line to break up the composition or appear to be growing out of the subject's head.

Exposure in all cases must be calculated for the highlights on the face or, in other words, the side which receives illumination from the main light source and in many cases the 18% grey card described in Chapter 7 will be a great help.

Fig. 44 *The beautiful quality of light from a window facing north is well exemplified here. The background was a white wall about 6ft back and a white sheet reflector was placed close to the camera.*

13: Portraits in the Garden

Choosing the background—garden props—best time of the day—posing outdoors—suitable clothing—the best lens —differential focus—glamour portraits outdoors

IT IS much easier to take portraits outdoors from the point of view of technical problems. Exposures are short enough to maintain spontaneity and the placing of lights is no longer a worry, but it is not so easy to be creative because some factors are not as easily controlled. Nevertheless it is worth giving some thought to overcoming these factors because portraiture by daylight, in colour especially, can be very rewarding. It is also an advantage to be able to work without a tripod.

The biggest problem in any garden photography is that of the background. The side of the house with a large area of brick wall may be tempting but it would be quite wrong because it would be too fussy, even if well out of focus. It would also be necessary to keep the camera square to the wall and absolutely upright or the lines of both horizontal and vertical joints would appear to be converging instead of parallel and upright. For colour photography, red is usually unsuitable as a background hue because of its 'advancing' nature (see Chapter 11).

If the side of the house is roughcast or painted white it could also be a temptation, but this would be very monotonous and uninteresting while there would be a risk of ugly cast shadows if the wall was facing the sun. Most of the other backgrounds found in the average garden—fences, flower beds and hedges are too fussy and even when out of focus look spotty. Very often they are, in any case, facing the wrong way for the light because the position of the sun will decide which way the subject must face. Indoors, the main light can be moved around the subject but outdoors it is the subject that must be moved.

Except where a specially suitable background is available, this means that the sky or the lawn are the safest backgrounds for most outdoor portraits.

An exception is a very thick and high hedge provided it is facing the right way and provided there are no gaps in it to let light through and make spotty highlights. Sometimes it may not be facing the right way at one time of the day but as the sun moves round it may become suitable.

This type of background is only appropriate when a dark background is required and normally the subject will have to be well lit to show up against it, but when it is right for the mood required, it can be most attractive, especially if kept a little out of focus. The dark green of a hedge makes a good background for most colour portraits but it should not be used when the sun is too bright and directly on it or the green may appear too yellow.

The owner of a garden with a tree in it is fortunate in having a good prop for the subject to lean on or peep around provided it is kept a little out of focus. It is especially useful for lively child portraits and for glamour pictures. Also fortunate is the owner of a swimming pool where active children can be shot almost as fast as the shutter can be clicked. This is likewise suitable for portraits of pretty girls posing on the edges or on the steps and there is the added advantage of being able to shoot on the side of the pool that is right for the angle of the light.

A gate leading out of the garden, or from one part to another, is also an asset when the sun is in the right direction because the subject can be leaning on it or over it. This will look very natural provided again that there is enough depth behind it to keep out of focus everything else that might look fussy.

The lighting for a portrait outdoors should be treated in exactly the same way as for a portrait indoors as described in Chapter 5. The subject should be turned so that the sun, whether direct or diffused, falls on the face at an angle that gives good modelling. It will be obvious that during the middle hours of the day the sun will be so high that it will fall at an angle of much more than 45° and this is unsuitable for any subject, even a powerful character portrait.

Therefore, serious outdoor portraiture should only be undertaken in the early morning or late afternoon when the sun falls at a suitable angle—45° or less, according to the modelling required. This has the added advantage of lower contrast and a warmer colour temperature. The sitter should never face the sun under any circumstances because it will give flat lighting and cause discomfort and squinting. The advice given by film manufacturers to have the sun over the photographer's shoulder is a safety precaution for snapshooters and not intended for serious photography.

Direct sunlight casts hard shadows like a spotlight and it is not ideal for portraiture except when strong modelling suits the subject—usually a middle aged or elderly male with a lot of character in his face. It has the disadvantage that some form of fill-in light will be required to illuminate the shadows which would otherwise be completely devoid of detail. This means using strong reflectors or fill-in flash. Reflectors can be a problem, especially if there is any wind, unless one has an assistant to hold a large card or a newspaper at exactly the right angle, so synchronized flash is better and its use was

described in Chapter 7. Sometimes, however, it is possible to arrange the subject near to a wall or other reflecting surface so that it acts as a suitable reflector. This, of course, is only possible when the sun is shining at an angle that causes the wall to reflect it at the correct angle to reach the shadow side of the sitter. The degree of contrast can be controlled by varying the distance from the reflecting wall.

For all other subjects diffused sunlight is much better but it cannot be emphasized too often that, even when the sun is completely obscured by cloud, the light is still directional and the sitter must be turned to receive it at the correct angle for the type of modelling required, just as for direct sunlight.

This means that it is still better to take the pictures early or late in the day even though the degree of diffusion may be such that the light looks similar in character and colour all day. When the sky is very heavily overcast it may be a little too blue for colour portraits and a UV filter will help to give it some warmth. This, however, is purely a matter of taste: colour is very subjective and some people prefer a warm overall appearance while others prefer a colder look.

Contre-jour lighting, which means shooting with the sun behind the subject and not behind the camera can be very attractive especially for a glamorous blonde or fair-haired child. It will produce an attractive rim of light around the hair and it is easy when the sky is overcast because the contrast is low. Normally it is such that no fill-in will be required but for black and white it may be desirable to fire a flash at an angle to obtain a little contrast and modelling in the face (see Chapter 7).

When the sky is being used as a background it is essential for the subject to be placed so that the lighting comes from well to one side, otherwise the blueness of the sky may be reduced. Tone may be lost if working in black and white and a filter may be necessary, but this should be avoided if possible because it makes lips too pale and eyes too dark.

Posing outdoors

Most people feel much more at ease when being photographed outdoors because there is no lighting paraphernalia to give a studio atmosphere. This means that the photographer does not have to worry so much about getting natural expressions or poses, but he will still have to exercise some direction and decide where to place the sitter and even decide on a basic pose.

The possibilities are endless but the beginner might well start by using a garden seat and turning it to the direction required to obtain the right angle of light on the face. In fact he can treat the subject just as he would indoors as described in Chapters 5, 8 and 9. With a much broader spread of lighting and more room to manoeuvre the garden also provides a good opportunity to take three-quarter and full-length portraits as well as close-ups.

This will mean the inclusion of quite a lot of the seat as well as background so the seat should not be obtrusive and a white painted version is usually

Fig. 45 *There is no end to the scope provided by natural props in the garden. These portraits show a variety of treatments, composition and lighting—all of which are possible at home. The two top pictures and the lower left-hand picture were taken in overcast lighting and the bottom right was in bright sunlight using flash fill-in.*

unsuitable. Likewise the clothes should match the scene. Formal wear would usually look out of place in a garden and so would a bikini unless the shot is taken by a swimming pool.

A solid garden seat or a low wall can be an advantage for some against-the-sky shots. If the subject stands on it the sky can form the background without the camera having to be held too low. It will be appreciated that a camera viewpoint on the ground will be an advantage in making a subject look taller and slimmer but it will also cause foreshortening, and if the face is turned down to look into the camera the eyes will be in shadow and reduced in size, while the chin will be emphasized. In a small garden, a low viewpoint may be necessary to avoid having a fence, wall or hedge in at least part of the background, but raising the subject will often overcome it. Children generally love climbing and they will sometimes allow themselves to be photographed standing on a wall or balancing along it when they would object to being posed on the lawn.

It is necessary to ensure that the wall or seat is in the right direction and that the child walks or faces a direction which is at an angle to the sun. No child should ever be photographed facing the sun because, apart from the certainty of squinting, the harsh lighting is inappropriate. A long-focus lens is a great help, even if it is not desired to fill the whole negative with the subject, because it saves one from getting too close to the child and frightening him, or distracting his attention. A long-focus or telephoto lens also helps to get out of focus backgrounds in confined spaces where a standard lens might render them too sharply, even at full aperture.

When concentrating on gaining a subject's interest it is all too easy to forget the background, which ought to be out of focus to some degree in any portrait. It must never be forgotten that the viewfinder of an SLR camera shows the picture at full aperture and when any other stop than the largest is used for the actual taking the background will come out sharper than it appears in the viewfinder. Conversely, the viewfinder of a non-rangefinder camera shows everything in sharp focus so the depth of field can only be read by consulting the scale on the lens mount, and even then the exact effect can only be assessed by experience. However, it is better to have the background too much out of focus than too sharp.

There are many ways of getting a subject, even a small child, to stay in one place and the advantage of using one of them is that it becomes possible to pre-plan the shot for lighting and background, and even to pre-focus. For example, a doll's house or other plaything which is too heavy for the child to move, can be placed in a suitable position. A portable rubber paddling pool can be put in a position which will encourage the child to face in the right direction. Rocking horses and swings can also serve and all that is required is some foreknowledge of the child and its interests to think up a suitable prop.

Fig. 46 *There is plenty of room for humour in portraiture and the relaxed atmosphere of the garden will often bring it out. Notice the excellent modelling produced by the overcast daylight.*

Glamour portraits

The garden often provides an ideal setting for glamour photography. That does not include pin-up photography which is more appropriately executed indoors, even in the bedroom. True glamour photography merely means presenting an attractive subject in a flattering way, sometimes but not always, with a sexual or erotic charisma but always in a very feminine way.

This does not necessarily mean creating the pastel euphoria of a Mayfair fashion salon but creating and projecting sparkle. Soft focus can be effective because it flatters but it is only appropriate when there is plenty of contrast such as one gets with contre-jour lighting.

Glamour is often associated in the mind with evening dresses and tiaras but this would be absurdly out of place in the garden and it is better to think of it in terms of pretty girls in natural settings, presented in a flattering way and with plenty of vitality.

Posing is usually no problem. Leaning up against a tree is always a good pose for a full-length picture and peeping round it makes a good half-length or close-up presentation. Leaning over a gate is also an easy one for many subjects. An appearance of glamour is often given by having both foreground and background well out of focus. If the model can duck down in the middle of a flower bed so that she is rising out of a diffused riot of colour in the foreground, and with the background also well out of focus as well, a very attractive colour shot can result. This is one occasion where a spotty background, such as a hedge with gaps in it, can be justified as long as it is so much out of focus that the highlights become luminous blobs.

Likewise, if a tree with low branches is available the leaves can be parted so that the subject is framed by out of focus leaves, preferably side lit so that there is plenty of sparkle. In the winter, glamour pictures are a possibility, even when there is snow everywhere, and the leaves of an evergreen tree or bush carrying snow or frost make an equally good frame. Without this a good picture is often possible by framing the head with the fur-lined cowl of a coat and if the latter is in a warm colour so much the better.

Another popular way of framing a pretty face is to have the subject holding a parasol, and if it is arranged so that the light shines through it, a very pleasant luminosity will be imparted to the picture. The lighting for this sort of subject should always be in fairly high key so that a happy or gay atmosphere is projected and the light can also be a little more frontal than it would be for one where maximum modelling is essential. If the picture is taken against the light and a fill-in flash is employed the latter could also be a little stronger, even to the point where another photographer might recognize it as fill-in flash. In all other cases the strength of a fill-in flash should never be enough to make the viewer aware that it was used.

Obviously, suitable clothes should be worn and summer frocks are usually more appropriate for glamour than jeans and T shirts. There is nothing against the latter and they can well be worn for a more candid type of portrait but they do not go with glamour. Bikinis and swimsuits are also out of place

Fig. 47A *Shooting against the light adds sparkle and the grouping in this shot has unity because of the communication between the two children.*

B *This is more posed than the picture above so one boy has been deliberately kept a little out of focus so that the other has become a principal point of interest and so maintained unity.*

except when a swimming pool, or part of it, is included in the picture. Being outdoors, a picture hat is in keeping and often helps the feminine effect. When worn it can frame the face nicely, especially if the sun is shining through the hat, and it can be a means of introducing hands into the portrait.

As with most types of outdoor portraiture, hazy sun is better than bright sunlight. It is not only kinder to the fleshtones, the sitter is more at ease and smiles come more naturally. Focus should always be on the eyes and it sometimes helps to use a slightly lower viewpoint while the model leans forward slightly with her head turned a little away but with the eyes turned to the camera.

The photographer should look for unwanted details because the sitter cannot see them if she is holding a particular pose. Such things as a slipped shoulder strap, the edge of a bra or an ugly crease can easily spoil an otherwise glamorous effect. Hair blowing in the breeze can be attractive in an outdoor picture but unwanted wisps over cheeks or eyes will not look good.

14: Group Portraits

Mother-and-child portraits—child groups—large groups—wedding groups

PORTRAITURE of more than one person is not difficult if the principles of lighting so far described are observed and if care is taken to compose the subjects into an artistic grouping.

The most common subject met by amateurs working at home is a mother-and-child picture. This is easily arranged indoors and if limited to a half length or head and shoulders they can be photographed satisfactorily in quite a small room.

Since there are two faces to be lit and they may be facing in different directions a hard main light will create difficulties so a very diffused flood or umbrella flash is an advantage and the soft light they give happens to be appropriate for this particular subject. Outdoors, a diffused light such as hazy sunlight is also suitable for such subjects, especially in colour.

Posing should not be a problem if one remembers that the subjects must be connected as a group. If they have equal importance and are not connected in some way they might just as well be photographed separately. One of the subjects must be made the principal interest, either by being bigger in the picture space, sharper or better lit. This of course is usually the baby.

They must also be connected in some way. This can be achieved by having them look at one another, by having the mother look at the baby, or by having the head of one overlapping the other. It is also wise to ensure that one head is higher than the other and preferably farther forward or farther back so that the monotonous effect of two heads in a row is avoided. It usually helps to have the heads inclined towards one another thus creating a suggestion of a triangular composition which has a lot of stability. If the child is young enough to be held in the mother's arms this becomes easy because she can follow the photographer's directions.

Photographing two older children together is more of a problem if they are old enough to be very active so ideally they should be encouraged to engage in some activity which keeps them in one place. In every other respect the procedure described for a mother and child can be followed but it is wise to arrange the grouping so that one child is just behind the other and prefer-ably a little higher or a little lower so that he or she becomes the principal

147

focus of interest. This is easy to arrange if one is taller than the other but in the case of twins a small stool may be necessary.

Wedding receptions at home provide a good opportunity for an amateur to take more spontaneous and artistic group pictures than the professional who must follow instructions and has probably taken his formal groups outside the church. A portrait of the bride and groom standing stiffly side by side, even though they are smiling, is not very satisfying. They should always be looking at each other and not at the camera and a pose in which the groom is standing behind the bride and looking at her over her shoulder while she looks up at him is much more attractive. This is also good for a close-up and, in fact, it is better to work mostly in close-up so that the concentration is on candid expressions rather than the bride's dress or bouquet.

In bright sunshine there is a danger that the texture of a white wedding dress may be lost, especially if the groom is in dark clothing and the exposure is based on an average. If possible it is better to take the pictures in overcast daylight or indoors by bounced flash in order to reduce contrast but, failing that, it is better to reduce the exposure so that the dress shows its folds and texture and let the groom's clothing lose detail instead. The disadvantage of this will be reduced if he stands partly behind the bride.

Larger groups

When there are three or more people in a group portrait it is essential to arrange them so that they are not in a straight line and this can make lighting by photoflood or direct flash difficult because they can cast shadows on each other. Here, again, hazy light outdoors or bounced flash indoors is the answer.

A group should never be posed like a row of soldiers. None of the heads should line up vertically or horizontally—this will give a static impression. The line should be broken by getting some to stand, some to sit and some to kneel and they should all be placed on different planes, i.e. at different distances from the camera.

Furthermore, they should overlap each other because gaps between them can be distracting and also destroy the impression of unity. It is a mistake, except for a very formal group picture, to have everyone looking into the lens, and conversation between the subjects should be encouraged although this has to be controlled or the group may be split into a series of smaller groups. There is also a risk of some faces being fully lit and others being in shadow, which will not please the latter.

Sometimes it is nice to arrange a group in a form of descending order such as a single file photographed from close to one end of the line. This is very appropriate when the subjects, such as a row of bridesmaids, are all dressed alike. The repetition of similar shapes gives a pleasing rhythm to the composition but monotony is avoided because none are the same size in the picture space. This is a case where they should all be looking at the camera and perhaps tilting their heads to do so.

All these arrangements are difficult with large groups indoors unless plenty

of room is available. It is probable that umbrella flash will not give sufficient coverage unless taken so far back that exposures become inconveniently long. It is therefore better to use the ceiling because the larger area will give a more even spread of light and it will be made much easier if two guns can be used. This will avoid the danger of any unevenness and, perhaps, a 'hot spot' in the middle of the group.

Since it is necessary in any group picture for all the faces to be recognizable it may be necessary to choose a higher viewpoint than normal, especially if some are standing behind others and are not much taller. This, in any case, is an advantage when flash is bounced from the ceiling, so standing on a chair will help. It is also possible to use photofloods bounced via the ceiling and this has the advantage that the effect can be seen before taking. However, the necessary exposure may be too long for hand holding the camera, especially when standing on a chair. One answer is to use a household step ladder and fix the camera to the top step with one of the universal joint camera clamps described in Chapter 1.

On the whole, it is much easier when lighting conditions are right, to take large groups in the garden but the ladder or chair may still be necessary. This means looking downwards so the background should be checked to see that it is not fussy or, if it is, that it is kept well out of focus.

In large group pictures it is much more difficult to create a mood as one can in a mother-and-child picture by posing and by differential lighting, so it is very important to ensure that the composition is interesting and not in serried rows or tiers like those once so popular pictures of the whole school or the regiment, which were arranged so that each face could be enlarged and prints sold separately.

15: Presentation

Mounting transparencies—projecting slides—portrait albums—framing and mounting

MANY people take good pictures and then present them so badly that a lot of their attraction is lost. There is not much point in taking a lot of care over the making of a picture and then showing dog-eared prints, carelessly-framed portraits, untidy albums or dust-speckled slides.

Mounting slides

The 35mm transparencies are returned from the processors mounted in card or plastic frames 2×2 in. These are adequate for a preliminary inspection in a viewer or for projecting to assess their quality, particularly sharpness. However, they are not satisfactory for serious use because the transparency itself is exposed and very vulnerable to fingermarks, scratches and dust. Furthermore they are liable to 'pop' in the projector when the heat causes them to expand or contract and this entails constant re-focusing.

All transparencies that are good enough to keep should be mounted between glass and there are several good proprietary makes of frame that are quite efficient but in course of time dust can get into them as well. The most satisfactory mount, and incidentally the cheapest, is one that can be made by anyone from materials that may be obtained from a photo dealer. The 2×2 in cover glasses are sold in boxes of 100 and the best type is treated to reduce the risk of Newton's rings which are concentric bands of coloured light that suddenly show up on the screen for no apparent reason. Ready-cut masks of black paper or thin metal foil hold the transparency in position and the sandwich of transparency between two cover glasses is bound up with a thin binding tape sold especially for the purpose. This tape can be bought ready cut with the corners mitred and, with care, this will make a slide that cannot collect dust, bugs or damp. It is of course essential to have a thoroughly clean transparency in the first place and it should be absolutely dry so an hour or two in a warm place, say on a radiator, is a wise precaution.

Masks can be obtained for 35mm, 126, half-frame and 110 transparencies and also with fancy-shaped apertures such as ovals, diamonds and rhomboids. These should be used with caution because they interrupt the smooth flow of a slide show but, nevertheless, a little masking is sometimes an improve-

ment. For example, an upright portrait of a formal nature or a full-length figure might benefit from a taller and narrower shape than normal.

Masking can be done with binding tape but the centre line of the picture must be on the centre of the slide. It looks bad when a picture appears on the screen off-centre and is followed by one that 'leaps' to the other side.

Every slide should be marked so that the projectionist knows which way to insert it in the gate or carrier. There are actually eight ways in which a slide can be 'spotted' for this purpose and only one of them is right. The universally accepted system is to put a spot about $\frac{1}{4}$in in diameter on the bottom left-hand corner of the slide when the transparency is the right way round and the right way up. The projectionist then inserts the slide into the

13 Slides should be 'spotted' in the bottom left-hand corner when held the right way up and the right way round. The spot will then come under the operator's thumb when inserting the slide into the projector.

projector or carrier with the spot under his thumb. Most stationers as well as photo dealers sell self-adhesive spots in different sizes and colours, and this makes classification of slides a simple matter. They can also be bought printed with numbers from 1–999, but most people prefer to write in their own numbers.

An alternative to the spotting system is to arrange a white strip along the bottom edge when the slide is viewed the right way up and the right way round. It is then placed in the projector with the white line uppermost and facing the projectionist, i.e. away from the screen. This method appears to be falling into disuse.

When binding slides in cover glasses rather than using the commercially made frames it is a good idea to place the spot on the inner mask and also arrange for titling or other data to go on it. This avoids any danger of spots or strips drying up and falling off the outer glass—especially important if the slides are entered for competitions and their return is required.

The total thickness of a slide should not be more than 0·125in and this is no problem if the materials sold for the purpose are used. It means, however,

that card mounted transparencies cannot be mounted between cover glasses with the card intact. The sandwich would be too thick for most projectors, especially those using circular carriers, and there would also be an undesirable air-space on each side of the film.

Showing slides

When selecting slides to make up a show, even just for friends and family, it is necessary to be absolutely ruthless and reject those that are over- or under-exposed. Sudden changes from thin to dense slides are irritating and hard on the eyes. It is also necessary to reject slides that are very nearly duplicates, however good they may be. A sequence of portraits of a little boy in the garden will only be interesting if each has a distinct message and if the boy is doing something entirely different in each picture. On the whole it is better to make up portrait shows as far as possible with pictures taken on different occasions with different backgrounds, clothing and treatments. Some variation should be introduced by interspersing close-ups with full-length shots and the time for each to remain on the screen can be varied according to the amount of detail. No slide, however good, should ever remain in view for more than 20 seconds, and no show should include more than 100 slides. Much of the attraction and luminosity of a slide will be lost unless a proper screen is used. Ordinary walls absorb too much light and often show their own texture.

For a really professional touch, fading and overlapping can be produced by using two projectors or a special dual projector together with some appropriate background music. Pulse synchronization is available on some projectors so that, in conjunction with a tape recorder, a commentary can be given and the slides changed automatically.

Portrait albums

Everybody is familiar with the type of photographic album, once so popular, in which scores of prints of equal size are mounted in symmetrical order by means of slits at each corner or by gummed corner papers. Modern albums fortunately give more scope for artistic presentation and for plenty of variety.

One type consists of loose-leaf sheets which are, in effect, envelopes of clear plastic into each of which a thin card can be inserted with prints mounted on both sides. This means that the colours of the cards can be changed to suit the photographs and to provide variety throughout the album. It is even possible to insert black cards with cut-out apertures to show transparencies as well. The sizes of the prints can be varied and, since the card must be provided by the user, the scope for variety is only limited by the imagination. The envelopes provide a considerable degree of protection for the prints and also add a glossy finish.

Another type of album consists of loose leaves of stout white card coated with a permanently tacky adhesive on both sides and covered with a thin clear plastic. The plastic is peeled back, the print or prints placed in position,

Fig. 48 *It is not always necessary to stick to standard formats based on manufacturers paper sizes. Often cut-outs or unusual shapes will give variety to an album.*

and the plastic replaced. This protects the prints as well as giving a nice glazed finish to them, and the prints can be removed and replaced as required. These albums have the advantage that no separate print mounting is required but on the other hand it is not possible to title or write on the pages and the user is limited to white card. Both types of album have a clean, modern look, and they permit an artistic arrangement of prints of different sizes. For variety

one can even mount cut-out prints and this is often a way of salvaging a portrait with a bad background.

The chief purpose of a mount should be to enhance the portrait and the tone or colour of the mount must be considered in relation to the overall tone or colour of the print. For example, a colour print which is overall light in tone and mainly in pastel tints will often gain luminosity by being mounted on black, and the greater the area of black the more effective the result. A colour print of this type which is only about 4×3in mounted on a 12×10in black page will actually look better than a larger print.

Sometimes a print in darker tones can also be mounted on black but with a thin white border separating print from background. Grey, red and deep green mounts are sometimes suitable for portraits and only personal taste can decide the ideal for each particular print and whether or not to leave white borders on the prints. If the latter are included, modern fashion demands that they are very narrow. The mounts to avoid for most subjects, especially in colour, are white, cream and blue.

Framing

There are many ways of framing photographs for wall display or for the table top but the best of them have one thing in common—simplicity. Elaborately carved wood or metal frames are out of fashion and so are large areas of white or cream mounting board. Framing is very much a matter of personal taste but it should always be considered in relation to the décor of the room in which the photograph is to be displayed.

One of the simplest and most effective methods is to mount the print on a stiff board or hardboard and trim it flush. A wood moulding about $\frac{1}{2} \times \frac{1}{2}$in or 1×1in, according to the size of the print, is then mounted on the back of the print around all four edges and flush with them. The moulding and the edges of the mount are painted red, black or some suitable colour, or alternatively covered with one of the metallic edging tapes that can be bought at many do-it-yourself shops. The final appearance is that of a solid block and it should be hung so that it is flush with the wall all round.

Another modern type of frame consists of very thick clear plastic and the print is sealed in the middle. This gives a rather unusual 'floating' appearance and it is suitable for standing on a table or hanging on the wall. The edges can be polished or framed in a simple aluminium strip. Colour portraits look very well in this type of mounting.

In a period or more conservative décor, framing with glass and a simple wood moulding is probably more appropriate. Wedge section mouldings in natural wood finish are available in many sizes for those who can make their own frames. These, of course, can be painted if desired. There are also a number of simple mouldings which fit well into period surroundings and most of them are white with a bead pattern picked out in gilt.

It is a curious thing that when a picture is block mounted without glass it looks better without a border, but when framed behind glass a border

usually seems necessary to separate the print from the margins of the frame. Without it there is often a 'crowded' look, especially if the portrait is large in the frame and has very little background. The choice of a border must depend to a large extent on the tone and colours of the portrait and often a fairly neutral colour such as a warm grey or dark green is suitable. In such cases the effect is sometimes enhanced by leaving a narrow white border around the print. It is always advisable before mounting a portrait, especially one in colour, to hold it against the intended wall or against different colour cards in order to assess the type and colour of mount required and whether or not to leave a white border.

It should be noted that colour prints tend to fade if they are exposed to sunlight for long periods so they should always be hung on the shady side of a room. Anti-fade varnish is available and this will prolong the life of a print but will not render it permanent. Cibachrome prints, being a silver dye bleach process, have a much longer life than prints made from colour negatives, but their possible life has yet to be assessed so these should also be hung away from direct sunlight.

Because of the necessity to hang colour portraits on the shady side of the room it will in many cases be an advantage to make the print a little lighter than normal. It is also very important to avoid the need to retouch spots caused by dust on the negative or in the enlarger. Spotting can be almost invisible when the print is viewed in normal circumstances but when hung on the wall the difference in texture between the spotted areas and the rest of the print becomes painfully obvious. Some retouching inks and dyes also change colour in time.

Care and attention to the details of presentation will ensure that all the work put into the making up of a good portrait photograph is not nullified and it will certainly lead to a greater appreciation by the viewer.